Nobody Knows

What Happened in Rwanda

Hope and Horror in the 1994 Genocide

Jean Jacques Bosco

Foreword by Dr. Darryl Plecas

tellwell 🖋

Tellwell Talent
www.tellwell.ca

ISBN
978-0-2288-2010-9 (Hardcover)
978-0-2288-2009-3 (Paperback)
978-0-2288-2011-6 (eBook)

Table of Contents

Foreword

WHEN I FIRST MET Jean Jacques Bosco I knew that there was something very special about him. But I didn't know what. I knew that I liked him, and I certainly loved talking with him about soccer. But he never talked about his time in Rwanda. He never talked about being on the ground in the midst of the genocide that happened there in 1994. He never talked about living through that hell, only to go through even more hell on a long road to getting his life back, from citizen of Rwanda, to refugee, to Canadian citizen. And thus he never talked about his biggest hell...traveling most of that long road as a suspected war criminal, guilty of mass genocide.

The irony is that Jean Jacques Bosco, as the book reveals, was the farthest thing from a war criminal. Rather, he saved people from war criminals. Indeed, he proved to be a man who found courage when he had to, and even more courage when he didn't have to. It mattered not that he witnessed the execution of so many people around him; he still plodded on with a deliberateness to save the lives of so many others. Yes, you get the feeling he was just plain lucky in facing danger and in escaping death for him and others at times, but at the end of the day, it is clear that his actions were nothing short of heroic.

Today, while an investigation of Jean Jacques Bosco by the National Security Section of the RCMP has cleared him of accusations of being a war criminal, he has still not received

justice. To the contrary, he experienced suspicion when he travelled abroad, and he still worries about his safety and possible attempts at prosecution if he went back to Rwanda. The prolonged stress has and continues to take its toll. Indeed, in reading the book you will likely feel that he has experienced a great injustice that has yet to be undone.

All of that said, the book is not about Jean Jacques Bosco. Rather, it is an account that clearly points out that the world still doesn't know the truth about what happened, and is happening, in Rwanda. There are many accounts of the genocide in addition to what Jean Jacques reports in this account. It is truly troubling that some seem to be ignored—or even worse—are actively suppressed. As Jean Jacques describes it, the issue has been a mix of misguided glamorization and whitewash. At the very least, one would expect that voices of concern would be given a proper judicial hearing, and to the extent that this hasn't fully happened, it is hard not to agree with him. Meanwhile, there are so many Rwandans who fled their country and who are now caught in limbo; afraid of what might happen to them if they return home, but also afraid of living in exile with regrets.

One thing is certain from this book: it is hard to be optimistic regarding the future of Rwanda and even harder to be optimistic about a genuinely helpful response from world powers. It's depressing, it's sad, and it is seriously troubling, but a very good read. The best part is that there are people like Jean Jacques Bosco who can inspire us to do better.

Dr. Darryl Plecas

Professor Emeritus

School of Criminology and Criminal Justice

University of the Fraser Valley

Acknowledgements

After 25 years, a written account of my story was both overdue and timely. For more than two decades I have been living with the need to tell my story to you, with friends and family urging me to talk about what happened. It is now timely to do so. Only now have I matured and healed enough to write from a more levelheaded and objective place. Had I written earlier, my story would have been tainted by the kind of blinding anger and passion that the atrocities of human butchering and extermination create in one's heart and mind. Time has granted me the deep compassion and clear understanding necessary to write from a place of greater objectivity. Make no mistake, however--I will always be scarred by the Rwanda genocide, separated from my loved ones, and Rwanda, the paradise-lost.

Without the inspiration of my dynamic and hardworking parents I would never have written this book. Though they have both passed away, I cherish memories of my mother Isabelle's smiling face, and my charismatic father, Gaëtan. To quote a Rwandan expression, *"they showed me Rwanda's sun"* on the day of my birth, August 1, 1966. I am also deeply grateful to my three children, Nicholas, Isabelle, and Clarisse. My

14 years old daughter, Isabelle Kathryn, at that time, eagerly proofread over 50 pages a night. She has my deepest admiration.

HERE ARE MANY THANKS to Kristine Charania, Dianne Cronmiller, and Courtney Konnert, for their time, insights and literary advice. Thanks also to Audrey Brashich for coaching and encouraging me to create the perfect manuscript. I would like to recognize the constant intuitive advice of J and C and their insistence to get things done quickly and *"en catimini"*.

Additionally, I am indebted to my current soccer parents and other numerous friends such as Sam S, Claver NZ, Eliz N, Emmanuel Z, Clementine L, Eddy N and others in Europe who urged me to speed up my project. Thanks go to Greg M and Bonaventure HB for sending me invaluable reference books written by ex-Rwandan military experts, FAR. Further gratitude is owed to my VCC Grade 12 English Instructor Mr. Dale Hunter and my UFV Professor Annette Vogt for taking the time to read my manuscript. Without Professor Vogt's lectures, I would never have had the confidence or passion to write this book, and to her, I am forever grateful. Special *"bow downs"* also to Dr. Darryl Plecas, Professor Emeritus, for taking the time from his busy schedule to read my manuscript and write the foreword.

I have certainly not forgotten all former Mudende students now exiled to two African countries France, Belgium, USA, and Canada who have provided me with forgotten, useful, and fearful details of our *"Five Days"* of trauma, when we were trying to flee Mudende at the time of the massacre. I must also extend gratitude to all my friends who patiently listened to my angry discourses against those who wronged Rwandans. I also need to recognize and give special thanks to my childhood

cousins of 28 years: *Côme, Cassien, and Alphonse*, the trio, who all succumbed to the brutality of RPF soldiers in 1994 and in 1998.

Heartfelt thanks to Koffi Wa Kankolonko, my Congolese High school teacher who sheltered me the first days of my exile in Congo, DRC, and to Emmanuel Zih and Esther Shikuku in Kenya. I am grateful for the hospitality of my Togolese friends, including Minister Sambiani Liwoibe. Many others have helped guide my life in the past 25 years: the Canadian JBST Dunbar Soccer Moms, the Belgians Live Boon Simoenis and Ward, Nelly Pulinx, and Frère François Buteeners.

I have been loved and helped by Rwandans, Africans, Europeans, Asians, Canadians, Americans, and South Americans alike. I am incredibly grateful to each culture for making me who I am today. The beauty of all human beings has contributed to my appreciation of life, death and all mankind. It is for these reasons that I write this memoir. I am compelled to dedicate this book to all of humanity, with the sincere belief that we can truly put an end to genocide.

Finally,

Primum vivere, deinde philosophari!

Chapter 1

HORROR

NO ONE **REALLY** KNOWS what happened in Rwanda, but I can tell you with certainty that on the evening of April 6th, 1994, my life's trajectory was forever altered. The twelve passengers on the presidential airplane weren't the only ones whose lives were shot down that night. My dreams for the future - and the dreams of over eight million other Rwandans - were crushed in the events triggered by this assassination.

The death of President Habyarimana was the final straw in what had been a protracted and violent battle for power between Rwanda's two dominant ethnic groups, the Hutu and the Tutsi. Hatred and violence between them is deep-rooted. Over four centuries[1] of intermittent power struggles have left a legacy of bitterness. In 1959 that bitterness erupted into what was called the Social Revolution, but was, in reality, a Hutu Revolution that killed many thousands of Tutsi, some Hutu,

[1] Tutsi king Ruganzu II Ndoli, 1510-1543, is said to have annihilated almost all the Hutu kings, or *Abahinza*. The Northern Hutu kingdoms such as Mulera in the modern Ruhengeri province, and Bushiru, in the modern province of Gisenyi, resisted annexation and remained independent until about 1912, when German troops helped the Tutsi king Musinga invade and annex them.

and a few number of expatriates in seven years of sporadic fighting with the Tutsi insurgency, forcing many others into exile in neighbouring Uganda. A thirty-year hiatus followed, during which conflicts lay relatively dormant and the economy boomed. But the Tutsi exiles in Uganda were eager to return to their country of birth, and in Rwanda, tensions between the remaining minority Tutsi and the majority Hutu still smouldered. In 1990, Tutsi who had been embedded in the Ugandan army invaded Rwanda and began a civil war. The war had been going on for four years when the plane carrying two Hutu presidents[2] was shot down. There could be no doubt that much bloodshed was to follow.

Throughout the evening of April 6th and long through the night I stayed glued to the radio. I wasn't alone: my whole university[3] of about 1,500 students was frozen in anxiety. Hour after hour we hung on to the national radio broadcast, hoping vainly for more information. We stayed up the whole night waiting for news, far too burdened by imagined dangers to sleep. By the morning of April 7th, ominous rumours were circulating about political assassinations in the capital, Kigali. And on the morning of the next day, April 8th, the threats of violence became real for us; by noon our once beautiful Mudende campus was littered with corpses. The bloodcurdling

[2] Both President Habyarimana of Rwanda and President Ntaryamira of Burundi were on the airplane. Both countries were 84% Hutu, and the assassination was seen as an attack on the Hutu people of all the African Great Lakes Region (Rwanda, Burundi, Congo DRC, Uganda and Tanzania). The assassination was believed by Hutu to have been carried out by Tutsi RPF forces under the direction of Major Paul Kagame.

[3] Adventist University of Central Africa Mudende was established in 1978 in the province of Gisenyi, but officially opened on October 15,1984. The campus closed in April 1994 due to genocide, but was reestablished in 1996 in Kigali.

screams had left little to imagine; the dead bodies of classmates strewn across the grounds removed all doubt. The sight and smell of blood was overpowering, and waves of terror and grief went rippling through the campus.

Tutsi students and staff members were being brutally struck down with sticks, stones, machetes, clubs and whatever weapons came to hand. Those who had not yet been identified as Tutsi were frozen in fear; Hutu students were too terrified to intervene to prevent further bloodshed.

In Rwanda today, as I write this, it is the Hutu who take the blame for the horrible acts of the 1994 Tutsi genocide, and it is taboo to make any reference to the 1996 Hutu genocide that followed. However, you cannot blame an entire ethnic group for either of these despicable acts. At the Adventist University of Central Africa Mudende, a few Hutu rose to the occasion to help save Tutsi and vulnerable Hutu alike. We risked our own lives, and managed to spare quite a few. But in the narrative that has been constructed since the 1994 genocide, those who did as we did have been ignored or used as scapegoats and hunted down by Kagame's regime, and the demonization of Hutu is thus complete.

I had nothing to do with the Tutsi genocide; I organized an evacuation from Mudende that saved many of my fellow students, both Tutsi and Hutu. But like so many others, I have endured years—and now decades—of discrimination and persecution. Rwanda can only heal as a nation when Hutu and Tutsi stop blaming one another for what happened. We must stop the cycle of lies, blame, and demonization that perpetuate hatred.

A few months after the start of the 1994 genocide, I began a life of exile. Like countless other Rwandans, I can never go back to the life I had. Twenty-five years later, the road of exile still stretches before me.

Chapter 2

BACKGROUND

WHILE THE RELATIONSHIP BETWEEN Rwanda's Hutu and Tutsi has long been a strained one, in the period of Belgian colonization tensions rose to murderous levels. As the new masters of Rwanda, the Belgians reinforced our perceived inequalities and hatred. Under their rule, racism grew between us. As will be explained, Belgian social engineering was the final trigger that set us against each other in two of the worst genocides the world has ever seen: the Tutsi genocide in 1994 in Rwanda, followed by the Rwandan Hutu genocide in the Democratic Republic of Congo in 1996.

It was 1916 when the Belgians took possession of Rwanda from the Germans, the country's first colonizers. At that time, colonizing countries subscribed to eugenic ideas, and Belgian officials quickly became obsessed with differentiating between the Hutu and the Tutsi peoples. The ethnocentric Belgians viewed the Tutsi as superior, believing that some with lighter skin bore signs of Caucasian descent and some of the taller Tutsi showed indicators of health and strength. They even measured the Rwandan's skulls, as was common at the time, and declared the larger-skulled Tutsi to be more intelligent. Constant reminders of these hypothetical differences were worn

on Rwandans' chests, in the form of mandatory identification tags declaring their ethnicity.

When the Belgians first arrived the Tutsi monarchy had been in place for centuries, ruling over the Hutu with absolute control and life-and-death power. For generations the Hutu had harboured bad memories of their treatment under Tutsi rule. The Belgian colonizers reaffirmed this power, allowing the Tutsi to maintain their oppression of the Hutu and the tiny Twa minority. The resulting deep resentment amongst the Hutu grew to violent levels, and in 1959 the Hutu rose up in what they called a *Social Revolution*,[4] but which was really a Hutu revolution. Thousands of Tutsi were killed in this upheaval. Many took refuge in Uganda, while others fled to Burundi, Congo, Kenya, and Tanzania. Many Tutsi from the ruling elite left of their own accord after the Belgians insisted that democratic elections be held, in a futile attempt to restore peace to the region. The Tutsi minority, comprising only 14% of the population, knew an election would remove them from all positions of power, and so they chose exile. Their refusal to cooperate with the Belgians' election strategy led Belgium to transfer their patronage to the Hutu and thus helped them move into elite positions in government and the armed forces. By early 1960 the Hutu held almost 90% of leadership positions, and had become the new rulers of Rwanda after more than four centuries of enslavement by the Tutsi.

[4] The 1959 Social Revolution was originally conceived by Hutu, Twa, and non-elite Tutsi as a new social, economic, and political order under which all three ethnic groups would have a role in governing the new democratic republic of Rwanda. This dream did not last long, and the Social Revolution quickly became a Hutu Revolution where only Hutu held positions of power, just as had happened under the Tutsi in Burundi. Rwanda's Social Revolution would last until 1994. It was then succeeded by a Tutsi Liberation war of aggression in revenge for the suppression of Tutsi under the Social Revolution.

Life for Tutsi in the Diaspora was in stark contrast to the privileged life they had led in the early years of the Belgian occupation. While some managed to form functional communities with access to good education, most ended up in derelict refugee camps with next to nothing. These tent-cities were dirty, disease-ridden places with no amenities, no educational opportunities and a minimal food supply. By 1963, the situation had not improved for the Tutsi. Frustration and bitterness continued to escalate and grow. Anxious to launch an insurgency, but lacking weaponry and external alliances, the Tutsi invited China to come to their aid. China proved to be of little help, and the Tutsi were labelled communists because of this association, giving Catholic Belgians yet another reason to support the long-oppressed Hutu. The Belgians had now made a complete about-face, garnering international support for the Hutu while condemning the Tutsi who had maintained their elite status for so long.

The Tutsi who had fled to Uganda in 1959 lived amidst that country's enormous ethnic tensions and tribal wars. Many were among the hundreds of thousands of civilians killed after Milton Obote came to power in his second presidency in 1980. Obote expelled almost 40,000 Rwandans back to Rwanda, most of whom were Tutsi. In 1982, Rwandan President Habyarimana would in turn send them back to Uganda. Bouncing between Uganda and Rwanda was a deadly and exhausting nightmare and many Tutsi lost their lives to starvation, sickness and violence. President Habyarimana had made the first of three crucial mistakes; Tutsi refugees were now convinced that they could only return to Rwanda by waging war.

Throughout the 1980's, we Hutu in Rwanda were kept completely in the dark by our government. I myself knew little about what was happening to the Tutsi Diaspora in Uganda until June of 1992, when I was attending a summer television

production workshop at the École Internationale de Bordeaux in France. A Ugandan Tutsi family living in Bordeaux invited me and two other Rwandans, two Hutu and one Tutsi, to have dinner at their home. We talked about Rwandan politics and the war, and I found myself trying to convince my hosts that the Tutsi RPF (the Rwandan Patriotic Front), would not be able to occupy even a square centimeter of Rwandan territory. I believed in the Rwandan Armed Forces' invincibility and I had naively accepted the Habyarimana government's narrative. Rugemampunzi, our host, shocked all three of us by showing us a film documenting the RPF's occupation of Kivuye and Butaro districts in Rwanda. I felt like a fool, and resolved to shut my mouth and enjoy the meal and the company as much as I could. A little while later, Rugemampunzi's wife burst out angrily, saying that after her husband's and her own family had been expelled from Uganda by Obote, and then were forced back to Uganda by the Habyarimana's administration, they had realized they could no longer live as stateless people. They were convinced they must return to Rwanda whatever the cost, for the sake of future generations of Tutsi.

After her passionate words, I had a clearer picture of what had motivated the Rwandan Patriotic Front. RPF media spokespeople had presented a complex rationale, but what our hosts told us made everything fall into place. In my home district of Kinigi over the Christmas holiday in 1981, I had seen refugee camps for the Tutsi who had been forced out of Uganda; when I went back in the summer of 1982, the camps were gone. I was told that the Tutsi had gone back to Uganda. The story was that Ugandan rebel leader Museveni and Rwandan President Habyarimana had made an agreement under which the Tutsi could go back and settle in Uganda in the territory controlled by the NRA, Museveni's National Resistance Army.

Museveni had, in fact, recruited many Tutsi refugees from the camps in Uganda and from among the 40,000 sent back by Rwandan President Habyarimana. The refugees were more than ready to fight, and happy to support Museveni, whose Hima tribe had historically been allied to Rwandan Tutsi. A few years later Museveni suffered a serious setback in 1985 when General Tito Okello, commander of President Milton Obote's Ugandan National Liberation Army, staged a coup d'état and sent Obote into his second exile, this time in Zambia.[5] But General Museveni and the National Resistance Army dug in and fought, and in 1986, they overthrew and exiled Tito Okello. Ironically, General Museveni received significant aid from President Juvénal Habyarimana of Rwanda − a second fateful error by the President.

Many of General Museveni's Tutsi soldiers now moved quickly up through the NRA ranks to become officers, including generals, in the Ugandan regiments. They became an overwhelming presence in the Directory of Military Intelligence, the Presidential Guard, in which Rwandan Tutsi Major Paul Kagame played a key role as Assistant Director. Even the Assistant Deputy Minister of Defense and Army Chief of Staff, Fred Rwigema, was a Rwandan Tutsi.

Soon after President Museveni seized power in Uganda in 1986, the Tutsi of the Ugandan armed forces who were determined to get back to Rwanda began pressuring President Habyarimana to allow them back into the country. He refused, declaring that Rwanda was already "overpopulated." This refusal and infuriatingly nonsensical rationale provided the stimulus for the Ugandan Tutsi's next move. Habyarimana's government had sown the wind, and the resulting whirlwind would erase every trace of the 1959 Hutu revolution.

[5] Obote's first exile was in Tanzania, after Idi Amin became President of Uganda in 1971.

In early 1990, many Ugandan political leaders were hoping to see the return of the Tutsi to Rwanda, including those in opposition to President Museveni, and those who supported him. The Ugandan people had made it clear to President Museveni that they did not want Rwandans in high military positions. As popular discontent mounted, Museveni considered initiating a war with Rwanda that would send the Tutsi out of Uganda to fight their way back into their homeland. However, Rwanda had Democratic Republic of Congo,[6] France, and Belgium as allies. Instead, President Museveni ensured the allegiance and support of the United States and the United Kingdom by convincing them that Congolese dictator Mobutu Sese Seko[7] ought to be overthrown. The USA was only too happy to help, as Mobutu, who was rumoured to have been an agent in Africa for the American Central Intelligence Agency (CIA) since the 1960's, had recently distanced himself from his Western allies. In their view, he knew too much and was becoming a thorn in their side. Their dislike of Congolese dictator Mobutu, and their desire to control mineral resources that lay abundant in Zaire, (later to become the Democratic Republic of Congo), encouraged the USA and UK to quickly support General Museveni's plan. Museveni had convinced his

[6] The DRC, Democratic Republic of Congo, was still known as Zaire at this time.

[7] Congolese dictator Mobutu Sese Seko also nicknamed himself Marshall Mobutu Sese Seko Kuku Ngbendu Wa Zabanga, which means "a warrior who eradicates everything that stands in his way." Mobutu had emerged as a journalist after a failed seven-year career as a Belgian foot soldier. He was carelessly appointed Army Chief of Staff in 1960 by Congolese Prime Minister Patrice Lumumba. With close ties to Belgium and the United States, some people believe that he became a CIA agent and overthrew Lumumba in 1960; he would do the same to Kasavubu in 1965. Mobutu amassed a large personal fortune through corruption and ruined the economy of Congo, despite its wealth of natural resources.

newfound allies that in order to succeed in the Congo they would have to deal with Rwanda first. The fact that Rwanda's weak President Habyarimana was a friend of Mobutu's, and had other unresolved issues with the USA, strengthened General Museveni's case. With USA and UK resources now at his disposal, he was in a position to trigger an invasion of Rwanda.

Despite these developments, the Tutsi were in no mood to wait and took matters into their own hands. Armed with Museveni's artillery and anxious to recover their right to reside in Rwanda, they began to organize as the Rwandan Patriotic Front under the leadership of Fred Rwigema, making plans to invade Rwanda. On October 1ˢᵗ 1990, dressed in their Ugandan uniforms, Rwandan Patriotic Front regiments marched from Uganda into Rwanda, overcoming the weak resistance of the unsuspecting Rwandan border patrol. President Museveni pleaded ignorance, but it is highly probable he knew of the attack and turned a blind eye. It was critical for him to have the Tutsi leave his army, in order to appease vocally disapproving Ugandan citizens and the opposition parties, and to remove a serious irritant from the complex balance of tribal interests in Uganda.

Though their surprise tactic had given them the upper hand in infiltrating northern Rwanda, by the time they had reached Gabiro, 60 kilometers south of the border, the rebels began to falter. The Rwandan Armed Forces (FAR) outnumbered the Tutsi RPF and they organized themselves quickly. The RPF took a hard blow when Fred Rwigema was killed on the second day of combat. The FAR grew in strength as France and Democratic Republic of Congo[8] came to their aid, increasing their manpower, organization and arms.

[8] Democratic Republic of Congo (DRC). This country was named Congo after its largest river by European explorers in 1884; Mobutu renamed it Zaire in 1971. President Kabila, who overthrown

They grew stronger still once they had clinched the support of Rwandan civilians, by staging a simulated attack on Kigali on October 4th,1990. At 2:00 AM, the FAR let off a barrage of gunshots and explosions that continued until the morning, while they broadcast the news that rebels were attacking the city. Frightened, the people rallied around President Habyarimana, who was in New York attending the UNESCO Summit. People quickly began to call out suspected Tutsi sympathizers, including southern Hutu who did not support Habyarimana, whose base of support was in the north.[9] In the aftermath of this staged attack, around 8,000 Tutsi, Southern Hutu and a few Northern Hutu were arrested across the country. This was the third of President Habyarimana's three fatal errors; it spelled the end for his mono-ethnic party and regime, and destroyed any credibility he previously had among southern Hutu.

Meanwhile, the Tutsi Rwandan Patriotic Front, who had not anticipated fighting a long or conventional war against so many men, began to fall back. The fact that they had lost their Commander in Chief, General Fred Rwigema, did not help their cause. Major Paul Kagame, who was training at that time at Fort Leavenworth in the USA as an officer of the Ugandan Army, returned to lead an RPF regroup. The rebels switched tactics to match their capabilities, and initiated smaller, surprise attacks. This guerrilla warfare would set the tone for

Mobutu in May 1997, renamed it Democratic Republic of Congo to differentiate it from the tiny neighbouring country, the People's Republic of Congo (Brazzaville).

9 Southerners were assumed to have been supporters of the first Hutu President, Grégoire Kayibanda, [1960 -1973] who was ousted by Habyarimana's coup d'état in 1973, and died in 1976 in his home, under a life sentence of house arrest. Once in power, President Habyarimana gave Northerners top positions in the military, government and civil service. This kind of patronage is commonplace in Rwanda and is known as "Regionalism".

the succeeding four years of conflict. It wreaked havoc on the psyches of civilians, who knew an attack could be looming anytime, anywhere. There were vast displacements of civilians. Up to 1.5 million people, an eighth of the Rwandan population and mostly Hutu, ended up in internal Rwandan refugee camps and turned the Nyacyonga neighborhood of Kigali into a gigantic tent city.

Hatred between civilian Tutsi and Hutu continued to boil, and violence between them erupted periodically. On January 23, 1991, the RPF entered the city of Ruhengeri, opened the Ruhengeri maximum-security prison and released Hutu military officers, including Major Théoneste Lizinde and Commandant Stanislas Biseruka, who had been sentenced to life for their role in the failed coup d'état against President Habyarimana in April 1980. These Hutu officers' hatred for Habyarimana trumped their ethnic loyalty, and they joined the RPF's cause.

At the end of July 1992, a cease-fire, supported by the international community, was called for by the Organization of African Unity (OAU). Two months later, talks began in Arusha, Tanzania between the Rwandan government and the Tutsi Rwandan Patriotic Front, mediated by President Mwinyi of Tanzania, OAU Ambassador Mpungwe, and with the participation of the USA, France and Belgium. Talks continued for months without arriving at any real solutions. On February 20th, 1992, a unilateral ceasefire was declared by the RPF, and they slowly began to draw their troops back. The country fell into an uneasy peace, with racial tensions at an all-time high. Under cover of the ceasefire, the RPF advanced on the capital in early April. Their army moved readily through Kigali Rural Province, but as they neared Kigali, they discovered that France had sent in enough troops and artillery to thwart their advance.

Meanwhile General Museveni was still facing pressure from his Ugandan constituency to remove all the Tutsi officers and troops from their military. It was time to take bold action. He needed to give the Tutsi the perfect opportunity to return to their homeland permanently. He organized a regional peace and security summit in Dar es Salaam under the auspices of Tanzanian President Mwinyi, who invited Presidents Habyarimana of Rwanda, Arap Moi of Kenya, Ntaryamira of Burundi, and Mobutu of Congo DRC, as well as all these countries' Army Chiefs of Staff.

Suspicious of the summit, Presidents Mobutu and Arap Moi opted not to attend. Ntaryamira and Habyarimana were more trusting. On April 6th, 1994 the summit was over, and President Ntaryamira of Burundi hitched a ride home in President Habyarimana's plane. He would never return home to Burundi; the plane was shot down and crashed in Habyarimana's own Presidential Palace gardens. According to the FAR, Hutu government, and local media, the plane had been shot down on orders from RPF leader Paul Kagame. The RPF and its allies, however, accused extremist Hutu in Habyarimana's inner circle, led by Colonel Théoneste Bagosora.

By April 1994, the Habyarimana government had become weak and erratic. Hutu opposition to Habyarimana was highly divided and vengeful, but Tutsi internal opposition was gaining confidence and bravado. The Hutu intelligentsia had a deep fear of being forced to share their jobs with RPF Tutsi returning from the diaspora. Young university students feared for their future prospects. Ordinary people, both Tutsi and Hutu alike, were targets for the RPF's and FAR's methodical assassinations and vengeful murders. The only groups that seemed to be happily benefiting from this chaos were the RPF and the murderous militias that had sprung up in the early 1990's and had already become deeply-feared, uncontrollable killing machines.

The death of President Habyarimana further undermined the Hutu's rapidly eroding sense of security. The past four years of civil war had radicalized the internal political opposition, creating a climate of extreme instability. The RPF's show of force intensified support for the ideology of *Hutu Power*,[10] and lent credibility to the Hutu extremists' propaganda portraying the RPF as an alien force intent on reinstating the Tutsi monarchy and re-enslaving the Hutu.

The political assassinations of several prominent southern Hutu politicians and military officers had added to the general paranoia, and the assassination six months earlier of the first Hutu President of Burundi, Melchior Ndadaye, by his Tutsi security units, was still fresh in people's minds. Many warning signs brought the Hutu's deeply entrenched prejudices about the Tutsi people bubbling to the surface. Some Hutu were now determined to make President Habyarimana's assassination the Tutsi's last move.

[10] *Hutu Power* was an ideology whose proponents held that, in implementing the Arusha Peace Agreement of August, 1993, Tutsi - RPF should only be given military and government key positions proportionally to their 14% percentage in the population. *Hutu Power* ideology originated from political opposition parties, including MDR, PL, and PSD. Habyarimana manipulated these political parties into splitting into pro-Hutu and pro-Tutsi (RPF) factions, in order to thwart Hutu Prime Minister Twagiramungu who had allied himself to the RPF. *Hutu Power* would coalesce with the MRND, Habyarimana's party, to form the interim Hutu government that ran the country during the 90 days of the Tutsi genocide (April -June 1994).

Chapter 3

SAVING LIVES AT MUDENDE

O N APRIL 6TH 1994, at 8:30 p.m., a few other students and I were tapping away at our typewriter keys, caught up in our usual evening typing practice class. We soon discovered that this night at Mudende would be anything but typical. Sammy from the Medical School rushed into the typing lab, wildly gesturing for us to turn on the radio, exclaiming that there was an airplane burning at Kanombe International Airport. We tuned in to Radio Rwanda; nothing else was being broadcast on any station but the crash. The next hour was filled with tension as more and more details were shared. Finally, at around 9:30 p.m. it was confirmed-- President Habyarimana's Falcon had been shot down. I glanced out the window and could see that all around the school students were huddled in big groups around portable radios. We all listened intently for new information, but the same vague message kept repeating every few minutes.

Students who had gone to residences on campus to watch the African Nations Cup soccer game held in Tunisia came rushing back to the classrooms. We pounced on anyone who came by on the chance they might have picked up new details

on international stations. We navigated between the different dormitories. As tired students drifted away, I went to my room where other students joined me, and we stayed up for hours spinning possible scenarios and imagining what they might mean for Rwanda's future. Some argued it was a mere accident, others assumed an attack by the RPF, and a few speculated on a military coup, but we had no real basis for any of our assumptions. Exhausted, I crashed around 1 a.m. for a few hours' sleep while others stayed up through the night. At 5:00 a.m. they woke me up to tell me that Colonel Bagosora had addressed the nation through Radio Rwanda, confirming the deaths of President Habyarimana, President Ntaryamira of Burundi, the Rwandan Army Chief of Staff, and a number of other military and government officials and flight crew, and recommending that people remain in their homes until further notice.

The Official Statement from the Minister of Defence

The Minister of Defense, with deep sadness, regrets to inform the Rwandan People of the unexpected death of the Head of State, His Excellency, Major General Juvénal Habyarimana, which occurred on April 6, 1994 around 8: 30 pm in Kanombe.

The aircraft carrying him back from Dar Es-Saalam was shot down by unidentified persons and in unclear circumstances. On board of the same airplane were His Excellency Mr. Cyprien Ntaryamira, President of the Republic of Burundi, who met his death with two of his Cabinet Ministers who were travelling with him; Rwandan Army Chief of Staff, Major General Déogratias Nsabimana; Ambassador Juvénal Lenzaho; Colonel Elie Sagatwa; Doctor Emmanuel Akingeneye; Major Thaddée Bagaragaza, and the entire flight crew, all of whom perished in this disaster.

The Minister of Defence asks the Rwandan People not to give in to discouragement after this painful event, and to avoid any actions that might harm public security. He especially urges the Armed Forces to remain vigilant, ensure the people's security, and maintain the courage and foresight that they have always shown in difficult moments. He recommends to the public in the same manner that they remain in their homes while awaiting new directives.

Kigali, April 7, 1994
Signed by order
Cabinet Director
Colonel BEMS Bagosora.

(Extracted from Faustin, Ntilikina, 2014, *Rwanda, Les Forces Armées: Répondre à l'histoire*, Editions Scribe, p. 277)

Like many others across the country, we suspected this might be a coup d'état, but on the whole we doubted it, as the message had said nothing about who might be responsible. We knew nothing about Bagosora that made us suspect him, especially in the current context of war against the RPF. Bagosora had retired from the army the previous year, and there were plenty of other senior officers who would have been more effective in such a role. Those among us who knew him from the army didn't think he had the personal authority to lead a coup, and we were tending to discount the coup theory anyway. Impatient as we might be, we didn't want to jump to conclusions.

We woke up that day expecting to hear more news of the President's death and the implications for the nation, but none came. We all stayed glued to our radios, looking for governmental instructions and gathering what we could from the BBC, RFI (Radio France International), Vatican Radio, and the Voice of America. Usually-compulsory morning prayers in the University chapel were only sparsely attended that morning, and though there was no official announcement suspending classes, nobody turned up there.

After breakfast, students wandered about in small groups, but there was nothing to do at all. When one Congolese professor who surprisingly did not know what had happened showed up that morning eager to start his class, the students jeered at him and gave him a hard time until one girl took pity on him and told him what had happened the evening before. The bad news about the aircraft crash was assumed to be known by everybody across the country, most importantly for a university professor. The University ceased to function that day; only the University switchboard stayed open at the students' request. We were able to make calls out to get more information about the crash and the reactions across the country.

At about 10 o'clock in the morning, we began to hear shocking rumours, none of which could be confirmed; first, that Prime Minister Agathe Uwilingiyimana, a Hutu, had been assassinated, and then later that Constitutional Court President Joseph Kavaruganda, also a Hutu, had been killed as well. A student confided to me that the son of Minister Nzamurambaho had been seen crying on campus and said his father had been murdered. At the same time the rumour spread that 600 Tutsi RPF soldiers who were barracked in the Kigali Parliament Assembly building to look after the security of RPF politicians had attacked the Presidential Guard in their camp two miles from there. Students had heard on an international radio broadcast that ten Belgian Commandos of the UN Peacekeeping force had been killed by FAR soldiers in Kigali Military Camp. News of killings in Kigali and across the country came thicker and faster. In the early afternoon we learned that another minister, Faustin Rucogoza, a Hutu, had been savagely assassinated by the Presidential Guard. Also, Minister Landouald Ndasingwa, a Tutsi, was reported killed. I quietly went to a former colleague from my high school teaching days, now a professor at Mudende, and begged to borrow his phone.

I called a friend in Kigali who I thought could provide me with inside information. He was able to confirm that the rumours in Kigali were identical to what I'd heard in every detail. I also called uncle Fidèle Ntuyenabo, my mother's cousin, who lived close to the murdered Constitutional Court President, to make sure he was all right. The housekeeper told me my uncle had fled to the Diplomat Hotel and then to the French Embassy in order to make his way to Burundi. Later on in Nairobi, he would tell me how a soldier had saved him and how other Hutu prominent officials had been warned and evacuated incognito to the Diplomat Hotel. It was a relief to

me to hear that he and others had managed to escape, but still I was in a state of shock.

Many of the reported assassinations were of people I knew in Kigali, the capital city since 1985. I had covered Prime Minister Uwilingiyimana's political events while I was working as a TV journalist at National Television. I had met Constitutional Court President Kavaruganda in 1985 in Kigali when I was looking for a job in different departments in the capital city after my high school graduation. I found him to be a straightforward and helpful man, who encouraged me to persist in pushing for interviews with company and department managers and went out of his way to give me a ride in his car reserved only for dignitaries; I had later become friendly with his son Marcel in Belgium in 1991. In fact, I had met and knew to some degree all but one of the assassinated politicians and administrators named in the rumours of that day. I had covered dozens of President Habyarimana's events as a TV journalist, and in that context had come to know most of the Rwandan officials who died when his plane was brought down. The faces of these good people kept appearing in my mind as I tried to make sense of what was happening.

Their deaths were discouraging for almost all Rwandans. We had hoped that the old days of human rights abuses in Rwanda were over – surely, we were past that by now. But here we were, facing new atrocities that shocked us to the core. Ironically, many of those responsible for the airplane crash eluded justice and remain free to this day.

The situation was dire for many students at Mudende, who came from a broad political spectrum. Some were from Tutsi and Hutu families allied with the Tutsi-dominant Rwandan Patriotic Front (RPF). Others had parents who were aligned with President Habyarimana, like the daughter of Juvénal Lenzaho, the President's Foreign Affairs advisor who had been

on the President's plane. Some of their families belonged to Habyarimana's inner circle – the National Bank Governor, the former Prime Minister, and colonels.

Mudende Adventist University had a good reputation and attracted a very diverse student body. Children of government officials and elite families had easy access through connections in the Ministry of Education. Other students, including me, were admitted on the basis of strong academic performance. Some, mainly southerners and even some northerners, belonged to the Seventh Day Adventist Church that ran the University. There were also at least five FAR junior officers who had enrolled after being wounded in the RPF-FAR conflict.

Students were Hutu and Tutsi, and their families might be aligned with either RPF or FAR, irrespective of their ethnicity. Remarkably, there had been no visible conflict or friction between students of different ethnicity or political allegiances. From what I observed, they became close friends even while their parents plotted against and slandered each other. One student I interviewed much later in exile told me that, though everyone knew that her father was a high-ranking RPF officer, she had been treated with respect by fellow students and University officials alike while she was in attendance there, right up to the disastrous events of 1994. It was truly remarkable that this campus was a place of unity and acceptance despite the racial differences that were tearing apart our country. I have often thought that if these Mudende students had been able to take their promised places in Rwandan political life with the values they had learned there, then perhaps there would have been no genocide in Rwanda or later in Congo.

Some Rwandans believe that the so-called Military Crisis Committee made two fatal errors in the first 24 hours of interim rule or vacuum following President Habyarimana's death: the assassination of Prime Minister Agathe Uwilingiyimana

and other opposition leaders, and the failure to stop the mass killings of innocent Tutsi and Hutu when the President's death was confirmed. All the abuses that followed were condemned by the international community, and led inexorably to UN Security Council Resolution 918 (paragraph 13) that imposed an embargo on the Hutu government just over a month later on May 17, 1994. The war against the RPF was over. There could be no excuse for these twin crimes: Rwanda's murder of its own citizens, and where the state was not actively killing them, its failure to protect them. These were heinous offenses that the international community could not tolerate.

Many Rwandans still believe that, had the Military Crisis Committee operated effectively during the first 24 hours after President Habyarimana's assassination, they could have spared the nation from the terrible events that ensued. The committee members understood the dynamics of the social, political, and military contexts that they were dealing with. In their books *Rwanda, Les Forces Armées: Répondre à l'histoire* and *Grandeur et décadence des Forces Armées Rwandaises,* both Major Ntilikina and Major Neretse criticized the International Criminal Tribunal for Rwanda for rejecting as mitigating evidence the calls to the populace for restraint by the Military Crisis Committee on that first day. But the Court reasoned that the intention of these appeals could not be taken into account, as the Committee had not supported those words with corresponding actions to protect human life.

Today, the commentaries of former Hutu politicians on the assassination of Prime Minister Agathe Uwilingiyimana and other prominent figures, both Hutu and Tutsi, appear preposterous and sometimes even sinister. Examples include a declaration by long-time Hutu Ministers Karemera and Ngirumpatse that the Prime Minister, because she was a member of the MDR party, an ally of the RPF, was therefore a

traitor who deserved to die. This may seem an incredible public position to take in the 21st century, but this kind of thinking is still commonplace in Rwanda. President Paul Kagame himself famously stated, "Habyarimana died, and I don't give a damn." Statements of this kind illustrate the profound disregard for the rule of law that prevailed, and still prevails in Rwanda. Leaders don't seem to care that their remarks enter the public record. It is common to hear Rwandan Tutsi leaders today making similarly self-implicating statements. Kagame's regime is no different from the vicious Hutu regime that succeeded President Habyarimana. When I read through my files or watch video clips of former Hutu politicians like Ministers Mathieu Ngirumpatse and Eduard Karemera, I just have to give my head a shake – these are law school graduates! How could they not know better? RFP military officers and politicians such as Brigadier General Nyamwasa, and Attorney General Gahima, who also hold law degrees, have left a trail of similar self-inculpatory statements in the public record. Despite their legal training, these men are among those most heavily blamed for Rwanda's tragedy. Although they should have known better than anyone the consequences of committing indictable offences, they acted as the catalysts of the Tutsi Genocide in Rwanda and the vast Hutu Genocide in Congo.

On the evening of April 7, the day after the assassination of the President, Mudende Adventist University registered its first casualty. Edmond Nzamurambaho, whose father Frédéric Nzamurambaho had been killed early that morning in Kigali city, was found dead. Students were now terrified they would be attacked by either Kagame's RPF or by FAR soldiers reporting to the interim government. Some female students suggested we should all sleep outside that night so it would be harder for assassins to target individuals.

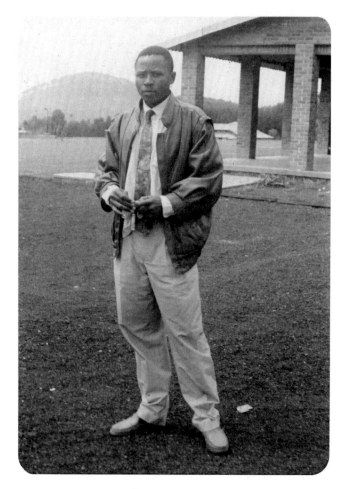

Here is where we, students, slept.

Students brought their mattresses from the northern dormitory where Edmond had been killed and joined us in the brush outside the administration building, where we would all spend the night. There were two different hearsay accounts of his death; one that he had been killed going to his dorm to get a sweater, and the other that he'd been out with a group drinking and celebrating the death of President Habyarimana and had been a random target. But common sense suggested that this

was a targeted assassination, and that someone on campus, a military student officer or a civilian student, had colluded with the killers.

The next morning, we all saw Edmond's body still lying by the cafeteria. It would stay there unattended through the whole morning. Edmond's friends asked us to say nothing about what we had seen, and nothing about the whereabouts of his brother, Raymond, who was still on campus.

We knew now that the country was in chaos, but we had not seen anyone from the district authority, nor had we been given any information or direction whatsoever by the university administration. I struggled to understand why we were left alone to protect ourselves. We decided to look after our own security by sleeping outside where it would be more difficult for the killers to find their intended victims. That night we dragged out our mattresses, pillows and blankets and piled them in the courtyard. No one wanted to live out the nightmare scenario of having their bedroom door kicked in by militia or soldiers looking for targets. We felt our chances of being taken and killed would be less if we stayed together. So, there we lay: Hutu, Tutsi, southerners, northerners, children of the RPF, children of government officials – all taking comfort in the group, grateful not to be alone. We did not sleep much, and those who did doze were plagued with violent scenes replaying in their heads.

We all made it safely through that night, but we would face scenes of slaughter the next day that were worse than anything we had imagined. The camaraderie and peace we had enjoyed together as students from Hutu and Tutsi backgrounds was now shattered. That day I would learn that ordinary human beings have a tremendous capacity for mindless violence and unspeakable cruelty, and I would understand for the first time that we are all only a few breaths away from being reduced to dust.

Chapter 4

APRIL 08 CARNAGE

F RIDAY, APRIL 8, 1994, was the third day after the Presidential airplane was shot down. By the morning of that day we could see nothing was going to be resolved quickly. Our classes were clearly not happening, and we met in random groups to figure out what we should do while we were waiting for either the government or university to give us some kind of direction. At around 8:30 am we were jolted back to reality by hair-raising screams, shrieks and shouts from the neighborhood around the campus. As we looked in the direction of the cries, we could see smoke streaming from several rooftops.

Despite the fact that we Rwandan students had all grown up in a country with pervasive violent conflict, most of us had never personally witnessed anything like this. Our international students, from many African countries and from Eastern Europe, were equally unprepared for such sounds. I think we knew that we were hearing screams of murder and death, but, unwilling to believe it, we stood there uncertain.

A female Tutsi villager with a baby in her arms and two toddlers at her heels rushed through our school gates. She looked around wildly, then ran into the nearest empty classroom and slammed the door behind her. Just as she did this, twenty or

thirty more peasant women and children, all of them obviously Tutsi, flew through our gates and dashed into the first empty rooms they saw. There they stayed in silence until, about twenty minutes later, in rushed the Tutsi men, bursting through the gates and jumping the fences, with over twenty Hutu peasants and militiamen running after them. Amazingly, the campus security guard, an unarmed local employee, was able to lock the metal gate before the Hutu were able to get in.

Mudende University.

The Tutsi men took advantage of this respite, and aided by a few women who brought them stones, made slings from whatever pieces of cloth came to hand and started hurling rocks over the walls at their attackers. The Hutu villagers, themselves armed only with makeshift and primitive weapons, flung the rocks back at them. These Hutu were impoverished, uneducated supporters of President Habyarimana or of the unsanctioned interim Hutu regime, and looked more like rabble than any kind of organized group. It is a sad reality that Rwandan peasants,

rural people; at that time were largely uneducated and naïve, easily able to be manipulated and blindly obedient to whatever faction was currently in power.

By now most of us students had gathered behind a fence, unable to tear ourselves away but wanting to shield ourselves from the conflict. From there we watched, aghast at the violence taking place on our quiet campus, and hoping to God that the Hutu wouldn't get in. But one of them, probably a militiaman, had a grenade; he pulled the pin and threw it among the Tutsi villagers inside the enclosure. The detonation shocked us into action, and we ran for refuge in classrooms and behind walls and lamp posts. This was no longer a game of sticks and stones.

The militiamen and villagers, country side residents, scrambled over the fence and started throwing stones and heavy sticks through the windows into the classrooms where the Tutsi were hiding. They kicked the doors in, and the Tutsi fled to the courtyard. With the gate still closed and a high fence all around them, they had no way to escape; the militia men and villagers ran them down and felled them with clubs and stones and machetes, battering, smashing and butchering every single man, woman, child and infant.

We were deeply shocked, rooted to the spot. We had not been targeted, but some of us already looked crushed and defeated. This would not serve us well in what was to follow. With the Tutsi peasants all dead, the Hutu killers turned their attention to students and marched on the women's dormitory. Those of us who weren't paralyzed in fear followed, some out of curiosity, others hoping to be able to ward off attacks on the female students. Now one of the Hutu men, a brutal and foul-looking man, began shouting for the girls to come out of the dormitory, and they all quickly came out into the courtyard. With images of the slaughter of Tutsi peasants fresh in our minds, a number of us shouted at the militiamen, some trying

to reason with them, others berating them. It was a futile, feeble effort; we felt powerless to intervene, and most only watched in frightened silence. My instincts as a television journalist kicked in; I was compelled to get everything down on videotape. I ran to my dorm room and grabbed my VHS camera. I rushed back and trained my camera on the militia and villagers. Even though I was filming from quite far off, a student shouted at me, "You know they're going to break that camera." His ugly tone told me that it wasn't the camera he was worried about; he was threatening me. He wanted me to leave the killers alone to carry on what they were doing, and I knew if he reported me to the militia, that might well be enough to get my throat cut. I lowered my camera and apologized for my actions.

The young female students stood hopelessly in front of the blood-spattered villagers and militiamen, who ordered them to declare if they were Tutsi, promising they wouldn't be harmed if they were. All stood silent and kept their heads down until one very bright student I knew from the Biology department, Jenny, raised her hand and looked the killers in the eye. "I'm Tutsi," she said defiantly. Immediately, three men smashed her to the ground with clubs and hacked savagely at her with their machetes, right in front of us. We couldn't believe what we had just seen, and some of the students literally fell down in shock. Girls were crying and young men were screaming; our courage, our humanity and perhaps even our lives were being ripped away from us.

There was no one to turn to for protection or for leadership; no one from the University had appeared since April 6th. We would continue to face the killers alone. Dr. Pearson, the University Dean, was away on a trip to South Africa and no one else seemed to have the necessary contacts and leadership skills to handle a sudden and violent crisis of that magnitude.

The Hutu villagers and militia started to call out names of individuals. Each girl whose name was called stepped forward and was butchered on the spot. Four innocent young women died, their young lives full of promise. I did not know these girls very well, but their deaths tore at my heart. I could imagine how their close friends and brothers and sisters felt as they watched. Some of us shouted at the men, saying that what they were doing was senseless. We wanted to do more, but we had no weapons, and their ruthlessness paralyzed us with fear. Many students drifted away, some no doubt because they couldn't stand to watch anymore, others from fear or to protect themselves from implication. It was clear that the villagers, killers, knew exactly who they were after, and it dawned on me that they must have had an inside informant. I was starting to sense that some of the Hutu students were very comfortable with the killing of their Tutsi classmates, and that it might be a good time to make myself scarce. I was stunned to find myself feeling unsafe among my fellow students. This was not the university I had known.

The violence did not end with the girls. The mob of Hutu villagers and militiamen now headed for the boys' dormitory, and we all braced ourselves for more hellish acts. Many of us followed; I went along. I wanted to witness all I could so that I could testify against the perpetrators, if there was ever an opportunity to do so. This time they called out only one student, Sebahakwa, whom I knew and with whom I had chatted from time to time. He was a Tutsi from the Congo DRC. Like the girls before, he fell under blows from machetes, clubs and stones. Apparently satiated, the mob then walked away, but not before dragging Sebahakwa's body to the cafeteria entrance, where they left it in plain sight as a reminder of the terror that was upon us.

Students began making their way to the cafeteria in silence, like automatons, out of habit. Still in shock, hardly anyone could say much. Most of the student body was there, but each of us was going through his or her own personal trauma, and I think we all felt quite alone within the group. Those who were Tutsi made efforts to connect with Hutu students, hoping to form alliances with people who might protect or shelter them in the coming days. They stuck close to people who had been kind in the past or who had reacted strongly against the morning's events.

Chapter 5

STUDENT SOLIDARITY MEETING

I JOINED THE TABLE OF my roommates John and Saab. They felt as I did that we needed to help the Tutsi students. Desperate for some kind of positive action, we came up with the idea of holding a meeting outside the cafeteria afterwards. I asked them to announce a meeting, which they did. Some students reacted negatively, saying that President Habyarimana had been killed by the RPF and the militia was simply avenging him, and "we're all Hutu, so what are you getting on about? Just let them do their job." But we pressed on and set up a student meeting. We stood outside the cafeteria and stopped each student as they came out from lunch, and most of them chose to attend.

There was no student union at Mudende, no structured student committees at all, and that contributed to the disarray of our student body —we had no normal avenues through which to organize, and we didn't have the habit of self-organization. However, it had become imperative to do that now. I knew

we had to put together a forum and get leaders to step up. Thankfully, some strong individuals, John and Saab among them, put themselves forward enthusiastically. Without that show of leadership, our situation would have been hopeless.

Outside the cafeteria, some students started to walk away, but John courageously pressured them to stay. Whether we could hang on to them was not clear. A few were fooling around as if to make light of the situation; one student said he was heading to the Engineering department to do some work and John blasted him, "You get back here right now!" I pinched John and whispered: *"Good! What kind of idiot is that guy?"* However, it's likely that the traumatic events witnessed by the students had left them completely unsure of what to do or how to behave. There is nothing that can prepare a person for an experience like this.

We could see that a lot of the students hadn't yet realized that this first massacre was not the end. In fact, it was a wake-up call regarding what was still to come. We needed to come to grips with what was happening on the campus and in the whole country, but most of these students had lived in a sheltered world, young and naïve about the political landscape. Many were recent graduates from remote secondary schools; many of them had never even been to Kigali. They were too inexperienced to piece things together and understand the enormity of the danger we were facing.

The students who finally attended the meeting were generally those who were shocked and traumatized by what they'd seen. They were functioning in a vacuum with no normal activities to take their minds off the morning's violence. A few international students from Congo DRC, Ivory Coast, and Mauritius came by to support us. They couldn't grasp the connection between the Presidential plane crash and the killings

on campus. We Rwandans got the connection, but we found it unbelievable as well.

The meeting started with vague remarks and everyone was looking around to see who would talk first. After a few minutes, some students started to ask what the meeting was about. In other cultures, someone might have asked, "How come no one is saying anything?" But for Rwandans, the meaning of this initial reticence could be formulated as, "This is no one's meeting. No one wants to be reported to the new and chaotic interim government as the person who called a student meeting at Mudende University on April 8, 1994; therefore, this is nobody's show." Rwandans, Hutu and Tutsi, tend to be cautious in public and weigh the consequences of speaking out. This is not surprising in our political climate of shifting power and allegiance.

I finally felt obligated to say something. It gnawed at me that university authorities had done nothing for our safety and no level of government had intervened to provide us with security. The campus had become a danger zone for every one of us. I spoke in French, Mudende's preferred language for official communications. I summarized the events surrounding the President's death, and talked about the deaths we had witnessed mere minutes before. I urged students as future leaders of the nation to exercise their rights and maintain solidarity. I pointed out that all of us were candidates for killing by the militia or villagers gone berserk, or by belligerents of either the RPF or the FAR in that remote area far from any effective control. I finished by proposing that we form a student committee to develop measures to protect us all.

This brief message got a very good reception. I could see many students felt relieved and re-energized. I knew there would be dissidents, but I hoped that positive messaging and some positive action would bring them on board. People asked

me to take on the leadership role, and to select the committee myself, but I said that was not what I wanted; I thought the team members all had to be equal. I urged the group to select a married student, a student from each faculty, and two female students. I ended up leading the team by default; however, I was confident I could get people working together and get things done.

It didn't take long for some enthusiastic students to fill each volunteer role, and we quickly broke off and met just off to the side of the whole group, promising to get back to them with ideas in 15 minutes. We knew we had to tackle the issues fast and come up with a workable plan on the spot. We came up with a number of ideas and took them back to the rest of the group for approval, as follows:

1) *We should be loyal to each other, and not get caught up in denunciation.*

2) *We should make a formal request to the University for evacuation to Gisenyi or another safe place.*

3) *We should formally ask for protection from the Mayor of Mutura District.*

4) *Any student who has lost their national ID card must obtain a Certificate of Loss[11] from the University.*

5) *We should request funds to cover our cost of living when and if evacuated to Gisenyi.*

[11] This item was my idea. The Rwandan government identity card was mandatory and identified the ethnicity of the bearer. In case of loss, the University had the authority to issue an interim Certificate of Loss of Identity Card, which did not indicate ethnicity. With this Certificate, a Tutsi student who had 'lost' their ID card could claim that they were Hutu. Doing so could save their life.

The students approved all five measures by acclamation and one student proposed we replace the word "should" with "must". That brought some laughter but all agreed to the amendment. Now we had to implement these five proposals effectively. We would hit the ground running, knowing there would be very little time to get things in place before the next onslaught of violence.

We could see the violence was likely to continue and affect more students. Blacklisting, blackmail and denunciations were all escalating and many students started to drift into despair. By lunchtime, just before our ad hoc meeting, five or six students had already come to tell me they had heard their names were on death lists. I knew we had to immediately push back against these lists, and we spoke out against them. We felt deeply that the Tutsi and the Hutu had equal rights to life in Rwanda.

Next, I learned that while our meeting and initial organizing was going on, the Vice-Dean, Dr. Willard Munger, had been getting the bodies removed from campus. Apparently, he had been overwhelmed by the unexpected bloodshed, but students who spoke with him and other Mudende University personnel said they seemed unwilling to help. Perhaps this sentiment was an exaggeration, but I wasn't surprised. It was consistent with the lack of action throughout the first three days, when they had made no formal effort to communicate with students, and, so we thought, had not made any request for assistance to the local government authority. There were rumours that they had called the nearby Bigogwe Military Commando Training Centre commandant for assistance, but we discounted that, since we'd seen nothing but marauding militiamen during that time.

Twenty-four years later, I would be able to confirm that the university administration had indeed requested assistance but had met with little success. Dr. Munger had called the Gendarmerie Commander in Gisenyi town around 10:00

a.m. on April 8th, and the Commander Major Biganiro had dispatched a group of gendarmes. On the morning of April 8th, Professor Jean-Luc Liénard had called his fellow Belgian, Major Willy Biot, at Bigogwe Commando Training Centre to request an escort for the University's evacuation, but with no success. His pregnant wife was due in two days and she went into labour during the evacuation. Despite their efforts, our confidence in our administration dwindled to nothing as the crisis continued.

But administrators and professors and some of their families did arrive while our meeting was still in progress, and when we finished, I went along with those who were able to bring themselves to see the aftermath of the massacres. The accounting professor, a Belgian named Jordan, covered Jenny's naked body with a blanket; students visibly felt grateful for this kind act. Professor Gerard Vymeister was there, holding his traumatized wife and the library director was there with his wife. Many of the Hutu students avoided eye contact with the Westerners and international students, fearing, I think, that they would be seen as somehow complicit in the killings. I went up and spoke with Professor Vymeister to deplore and condemn what had been done.

The presence of authority helped us snap out of our shock slightly, although many muttered their resentment that they had not been there earlier. When they offered us no emergency meeting or debriefing, people's level of frustration climbed again. But it was true that events had moved so quickly that no one could have predicted them, and we found out from some students that there had been previous clashes between Dean Robert Pearson and President Habyarimana's government; Dr. Pearson had closed the University doors at least two or three times between 1990 and 1994 to protest human rights abuses against Mudende students.

A very good thing happened a bit later that day; Lieutenant Théophile M. arrived at the University from Gisenyi Gendarmerie Camp with three or four armed gendarmes. He told me he had been dispatched to the Mudende campus at the University's request. Apparently Vice-Dean Munger had identified a gendarme student officer, Lieutenant Nduwimana, as an agitator while intimidating some students. He also said Dr. Munger had reported there were 500 bodies lying on the campus grounds, a great exaggeration, but it had gotten Gisenyi's attention. Lieutenant Théophile told me his orders were first to disarm Lieutenant Nduwimana, then put an end to the killing of the Tutsi students and lastly to secure the campus and protect the students from further violence.

I knew Théophile well; he had been my grade 11 student at Rambura High School when I had taught there five years earlier, and he had also stayed for a week at Mudende in mid-November of the previous year to help keep the peace during a student strike instigated by Burundian students. Having this humble and honourable junior officer on campus was a real gift; he was a professional, unbiased soldier who could be counted on to not take revenge for Habyarimana's death, as others had done. Former Mudende students remember him even today; some students attempted to bribe him to help them escape to Goma, but he refused, promising he would ensure their security and safety there at Mudende.

The Gisenyi gendarmes' first priority on campus was to get Lieutenant Nduwimana disarmed and under control, so they could hand him over to his Company Commander at Gisenyi Gendarmerie base. He had in fact been assisting the killers, as we students found out the next day. A girl named Céline from Kigali was being chased down by two villagers eager to kill her. Luckily, she saw me and other students coming her way and she yelled at the would-be assassins, "Ask Bosco if I'm not a Hutu!"

I looked straight at them and told them she was in fact a Hutu and my cousin. I did this to convince them they had made a wrong identification, knowing there was no obvious way to know who was Tutsi or Hutu.

Hearing what I'd said, the villagers paused and backed off. Céline stayed with our group. She told us that one of the students was accusing others of being Tutsi and had made a list of students to be killed. She'd been told this student was a junior student officer with the rank of lieutenant. I racked my brain to think who this might be but only had a vague recollection of the person they were talking about. We were eventually able to track Lieutenant Nduwimana down and found him in an agitated state, shouting that traitors had to die because they had wounded him at the battlefield. Fortunately, he did not have his pistol with him at the time.

Earlier, I had heard that there were students who were drawing up lists of Tutsi and Hutu students to be killed, and giving the lists to the militia, but I had no way of knowing who they might be. I had also heard there was a second wounded FAR lieutenant actively helping the death squads. It took us some time to straighten out who was responsible for what. Lieutenant Nduwimana, as it turned out, was mainly targeting girls and particularly those in his class. Both the lieutenants who were eventually implicated had been wounded during the FAR - RPF war; this was what had made them eligible for scholarships at Mudende. In contrast to these two, we also had Lieutenant Francis on campus, who had been my student at Rambura High School as well. Unlike the two ill-inspired lieutenants who had been helping the militia, he was very supportive in helping us save the lives of our Tutsi and Hutu classmates.

We asked Lieutenant Théophile to remove the militia and peasants-Killers from the campus area where they were roaming

freely and exercising ad hoc authority over the university complex. With his help and with the assistance of some brave students, we were also able to put a stop to the preparation and distribution of death lists; there had been a series of such lists and we had not been able to pinpoint where they were coming from. We had suspicions of who were behind them, but no proof. I confronted two students I suspected and told them they had to stop or they would be held accountable. They heatedly denied they had anything to do with the lists, but in fact we did not hear anything about lists being made or circulated after that warning.

The two wounded Lieutenants, who we referred to as 'crazier than the villagers,' were much harder to deal with than the list-making students. Without Lieutenant Théophile and his gendarmes' intervention, more Tutsi, and undoubtedly some Hutu suspected of protecting Tutsi, would have been eliminated. A simple denunciation was enough to get you cut to pieces.

Recently, here in Canada, I had the opportunity to ask one former Mudende student how the militia and villagers had been able to go straight to the students' dormitories and know accurately the names of the Tutsi occupants. He said it was no mystery, since village residents whose huts were around the campus did cleaning and laundry for students and were very well acquainted with individual students and their living quarters. As a relatively new student to the campus I was unaware of this, and didn't know the routines of campus as he did. He went on to say that the peasants had been waiting for opportunities to loot the students' dorms and the University's facilities. They had been taking students' clothes and jewelry immediately after killing them.

Now I understood it was not strictly about eliminating the Tutsi, but looting was also a key motivator for their savage

acts. A few days after the first massacres, just as soon as we finished evacuating Mudende, the University buildings and especially the dorms were savagely looted. The dorms were completely stripped of our possessions; we had left in haste leaving everything behind, hoping to come back in a few weeks. Villagers had come from miles around to join in the killing and looting at Mudende. Looking back and putting the puzzle together, and thinking about my own actions, I can now see how lucky I was to have survived.

The bodies from the massacre of April 8th were removed, probably to be thrown into a common grave somewhere in Mutura district close by. *May their souls rest in peace,* I thought. I have never forgotten the sights and sounds of their horrific deaths. I narrowly missed going into that grave myself; quite a few of the villagers, militiamen and students would have been very happy to remove my head.

Some brave and compassionate students helped clean up the remains, moving bodies into the back of a pickup truck. I could not face all the blood, choosing instead to spend time with some of the more traumatized students in an attempt to comfort them. Sensing that I was sympathetic to their plight, a number of Tutsi students confided in me. I felt honored that they would trust me, but I knew I still had to keep a low profile while offering them advice – I could not let myself be publicly identified as a Tutsi supporter.

Things did change for the better when Lieutenants Théophile and Francis threw their weight behind the security and safety measures we students had devised. I asked them to watch my back, and they did so with no hesitation. These two young lieutenants had been my students, but we were only two or three years apart in age; to this day I feel a special bond with them, and much gratitude for what they did in that difficult time.

Later that same afternoon, we heard about more massacres at Busasamana Parish seven or eight kilometers from Mudende, and in Gisenyi town 35 kilometers away, and indeed, all over the country. Thousands of Hutu militia, they said, were seeking revenge for the death of President Habyarimana, and were looking for looting opportunities. I assume these militiamen were like those I had seen on our campus: illiterate street youth, petty thieves and violent muggers.

The devastating story we were to learn much later was that the militia who had been killing innocent Tutsi and Hutu civilians, included among their numbers RPF-Tutsi agitators who catalyzed the bloodbath in a number of areas across Rwanda, and most importantly in Kigali. Abdul Ruzibiza[12] and other RPF dissidents would later testify that Tutsi RPF agents had infiltrated the Hutu militia and were more zealous in the 1994 massacres of Tutsi than their Hutu counterparts; this had been an RPF military tactic to bring about a collapse of authority in Rwanda and give the RPF a clear path to military victory. It was chilling to realize these Tutsi agents within the RPF were willing to massacre members of their own ethnic group in order to gain power.

The Hutu were not safe at Mudende at all. We now learned that while the Tutsi had been the initial target, the militiamen were going to go after moderate Hutu, southern Hutu and anyone suspected of having a connection with the RPF or having any compassion for Tutsi. In our group, there were students who belonged to each of those categories; one of

[12] Every Rwandan, and anyone interested in knowing the truth about the Rwanda Hutu and Tutsi genocides, should read RPF Lieutenant Abdul Joshua Ruzibiza's book, *Rwanda: L'histoire secrète,* 2005, Edition du Panama, 2005, Paris. The author has documented dates and places where Tutsi mass killings took place, and the names of Tutsi soldiers who perpetrated the killings.

them was the son of RPF Chairman Angelo Kanyarengwe. Recognizing early on that he was in imminent danger, Angelo had escaped into Mudende's surrounding Hutu village with the intention of crossing the border to Congo DRC. He was a prime target, and we agreed that should anyone make inquiries about him, we would simply say that unknown people had taken him away.

Chapter 6

ACTION PLAN

ON THIS SAME DAY of April 8th, we were already implementing our five-point action plan. Our agreed priority action was point three, requesting assistance and protection from the Mayor of the municipality of Mutura nearby. Saab knew Mayor Bakiye, and we tasked him to carry our request to the Mayor. We would not see him again for two weeks; he never returned to campus. In the interim, we had assumed the worst—that he had met with violence on his mission to Mutura. We later learned that the Mayor had strongly urged him not to return to Mudende, saying it was too dangerous there, and had begged him to go to his brother's house near Gisenyi where it was safer. Saab reluctantly agreed, and Bakiye provided him with an escorted vehicle.

When I found this out later, I initially judged him very harshly as a coward who had betrayed us. Though I understood the pressure he was under from the Mayor and his family, the stakes were very high for all of us at Mudende. We needed the Mayor's help, and we needed to know if that help was going to materialize. On top of all that, we were in agony of suspense, not knowing if Saab himself had come to harm in the horror of those first few days.

While we waited, we continued to work on our committee's first action priority: building solidarity among the students and putting an end to list-making and denunciations. Committee members and other engaged students continued to intervene with students who were making lists of students to be killed. No one ever admitted to making lists, but as we continued to bring attention to people we suspected, the lists stopped and disappeared.

Lieutenants Théophile and Francis also contributed to the process of de-escalation by challenging villagers and militiamen who had been terrifying students. I know there were many students who took risks and tried to deflect the violence, and who never got any credit for their actions. They deserve recognition and gratitude from all of us who were there and suffered through those days.

We also engaged the university authorities the same day, April 8, asking them to evacuate students to a safe place, preferably Gisenyi.[13] We had heard that a UN convoy was going to evacuate international students and expatriate professors and staff from Mudende to Gisenyi the next day, Saturday April 9th. A delegation from our committee approached the University's Academic General Secretary with two proposals: that we be evacuated with the UN convoy the next day, or that the University would make vehicles available to us so that we could undertake our own evacuation. The University's Academic General Secretary and other administrators weighed these requests and decided to provide us with a bus, a minivan with an attached trailer, and a pickup truck so that we could evacuate ourselves. We were disappointed not to have UN protection but relieved that we had a concrete way to get out of

[13] We assumed that there would not be much killing going on at Gisenyi City as it was a provincial capital with a Gendarmerie base, an FAR garrison and the Governor's offices.

the violent rural area that surrounded Mudende. All of us were desperate to leave; the once-beautiful campus of the Adventist University of Mudende had become a nightmare for us.

We also requested that the administration make money available to students for living expenses during the evacuation and on their journeys back to their home provinces. We didn't have a clear picture of conditions in Gisenyi, nor did we have any idea of how long our journeys might take. The Financial Assistance Department did make small loans to students; without this many would have been in dire straits. Personally, I wasn't too concerned about money at the time, but later I would wish that I had been more proactive. I left quite a bit of money in my student account, money that would have been very useful later on when I fled Rwanda altogether.

The remaining item on our committee's action list was to devise a scheme to help students whose government identification cards identified them as Tutsi. These ID cards had been institutionalized by the Belgians in 1935[14], and they were a death warrant for any Tutsi interrogated at militia roadblocks. I had come up with the idea of requesting a Certificate of Loss from the university administration, a certificate that could spare the bearer the serious consequences of having no ID, while enabling them to hide their ethnicity.

To encourage Tutsi students to come forward, I would make it clear that no one wanted to see their identification cards and that all they needed to do was to declare that they had lost their ID. This protected me as well; no one could come out later and accuse me of reporting their ethnic identity to others, as I had not seen their cards.

[14] In Joseph Sebarenzi's book with Laura Ann Mullane, 2009, God Sleeps in Rwanda: A Journey of Transformation, Editions Atria books, New York, Page 13.

We made an announcement in public that students who had lost their ID could come with me to the University's Academic Secretary and get a Certificate of Loss. I said nothing publicly to connect any of this with ethnicity or to direct it to the Tutsi students, which would have alerted militia agents among the student body. It was just an innocuous notice to any students who had lost their identity card, logical enough considering all would be travelling and passing through roadblocks. As students came forward, I took them to the office and they got their certificates. There, I would also suggest privately to these students that they might want to 'lose' their original ID cards. I had talked with the University's Academic General Secretary about issuing Certificates of Loss; he thought it was brilliant and gave it his full support as it was making sense. Not only Tutsi, but also Hutu who had really lost or misplaced their ID cards received these certificates. Without an identification card they were open to accusations of being RPF spies, Tutsi or traitors of some stripe, and might be killed at any of the militia or FAR roadblocks that had sprung up all over the countryside. No ID meant capital punishment without due process. To have an official university document verifying you had lost your identification card might well save your life.

Our plan worked. As we had hoped, we were able to evacuate Hutu and Tutsi from Mudende to Gisenyi with Certificates of Loss, and southern students were able to get all the way back to their home towns using them. The Tutsi who remained in Gisenyi town and elsewhere in Gisenyi province relied on them until they were eventually able to reach relative safety in Congo.

By the end of Friday, April 8th, the same day our committee had formed and drafted our five action items, we had successfully completed four. Although we had not received word from Saab or the Mayor of Mutura, all our other initiatives had gone well and we had all worked tirelessly. But our work was not yet over;

the students were preparing for the following day's evacuation. Late in the afternoon, I went to the university garage to pick up the promised bus from Mr. Fortney, a Canadian engineering professor. He gave me the key to the Toyota Coaster bus and helped me prepare it for our journey, with supplies and extra gas on board. He also prepared me for driving it--I was accustomed to driving my little Fiat Ritmo and had never driven anything larger, but by the time I got through the cornfields between the garage and the main campus, I felt confident I wouldn't kill anybody with it. In any case, I thought, all of us would much rather be killed in a car accident than butchered with machetes, clubs, and stones.

I was ecstatic to have the bus ready for action, and confident that the evacuation would proceed on Saturday as planned. I told some of the most vulnerable students very discreetly that we were close to being able to leave, just to keep them from despair. Nevertheless, the threat from the villagers and militia was still present, and I knew more violence could erupt at any time. We also feared the RPF might infiltrate the area and take revenge for the slain Tutsi, just as had happened one night late in November, 1993, when an RPF commando launched a raid and killed several Hutu and Tutsi at Kabatwa in Mutura district, only a few miles from Mudende University.[15] People at Mudende remembered this incident and it was part of the reason that almost all the Hutu students, especially those from the south who were increasingly being targeted by the militia,

[15] RPF Lieutenant Ruzibiza, quoted in *Rwanda: L'histoire secrete*, and other RPF defectors, described how a special death squad from Charlie Mobile unit under RPF Lieutenants Gashayija Bagirigomwa and Moses Rubimbura, attacked and killed Hutu and Tutsi civilians at Kabatwa in Mutura district. This Tutsi RPF killing squad simulated the Hutu militia's killing methods in order to deceive the international community into thinking that the massacre had been committed by Hutu affiliated with anti-Tutsi political parties.

supported the evacuation initiative. My own fear was of being targeted by extremist Hutu students who might denounce me to the militia, villagers and army deserters as a traitor for protecting Tutsi.

That evening, traumatized and depressed as people were, we all gathered in the cafeteria to get some food. Just as we had seated ourselves at our tables, an armed soldier burst into the cafeteria and sent us all into a state of panic. Would he throw a grenade, as we'd seen that morning? The uniformed thug stared fixedly at a young student at the next table, and shouted angrily at him: "Where is Raymond? Point out Raymond to a student named Bosco!" Raymond Nzamuramabaho was sitting at his usual table, right beside the student the soldier kept staring at. There were only three students at that table that night, as Raymond's brother Edmond had been killed the night before. The young student hesitated, and the enraged soldier slapped him heavily across the face. When the soldier turned his attention to another table and started asking the same question there, Raymond quietly stood up and walked away.

Everyone in the room was relieved to see Raymond escape through the main entrance. As the agitated soldier kept roaming around asking the same question, students shouted angrily, "He isn't here!" The soldier, likely a deserter from the FAR, stalked out and a few seconds later we heard some gunshots. We assumed the soldier had caught up with Raymond and shot him, but fortunately, that was not the case. The rumour was that gendarmes had been firing shots in the air to frighten the soldier off the campus. Later that evening I approached Lieutenant Théophile about the shots we'd heard; he said that there was a FAR platoon stationed 3 kilometers from Mudende at Kabuhanga, near the DRC border, and the deserters were coming from there. He thought the platoon commander was likely unaware of the actions of these individuals from his

command. He denied that there had been any exchange of gunfire between Gendarmerie and FAR, which I took to mean, it's none of your business. After that incident, we rarely saw soldiers and heard no more gunfire.

Most of us got little sleep that Friday night, which to me seemed twice as long as the day had been. I believe that was true for most people at Mudende; it must have been worse for those who knew they were being targeted by killers. If I had a chance to meet all those students again, I would be eager to know and document what went through their minds that night. Some clearly did not believe in the reality of what was happening to them. Personally, I have relived those five days in April every day of the last 25 years. I don't know how I survived; I can't imagine doing today what I did then, were I placed in similar circumstances. It remains a mystery to me, and though profoundly traumatic, it has empowered me in many ways.

Today, whenever, I get the chance to be in touch with former Mudende students after more than 25 years, Hutu or Tutsi, we always spend some time recalling those five shocking days. We may have forgotten some details and dates, but the horrible scenes are burned in our memories no matter how hard we have tried to leave them behind. It has taken me 25 years to heal enough to be able to write about it, and to look at the facts and the events with some detachment.

These events are part of my life's story and it would be impossible to leave them behind. They are engraved in my mind, and there is no point denying them. I've finally decided that I have to share this with people; I witnessed first-hand the deaths and traumatizing of innocent and vulnerable people. I observed heinous indifference, cowardice and vengefulness; and I saw courage and heroism to balance these things, all during those nightmarish five days on campus. I witnessed professors, administrators and students utterly failing to organize and

resist the crazed villagers and militia, because of the strongly entrenched hierarchical separation between them and the students. There was no forum in which we could communicate and unite to build a coalition that might have held off the worst of the violence until the Gisenyi gendarmes were able to reach us. If I was able to achieve anything at Mudende, it was because of my several years' experience in national and international media, and life experience and study in Europe. Through these lenses I could see that people could be brought together and that some level of solidarity among the diverse groups at Mudende was possible.

My work in Rwanda National Television provided me with a higher level of understanding of the events that were happening. I had covered Major General Paul Kagame at RPF High command base at Mulindi, and I had also covered local events for President Habyarimana; I knew other Rwandan opposition leaders and I had a sense of what the political apparatus looked like at the time.

Some people inside and outside of Rwanda thought of Habyarimana and Kagame almost as mystical beings, believing that the death of either one of them could send Rwanda into chaos. I didn't believe that then, and I don't believe it now. Despite their office, a president is just a person, while a country is a long succession of generations. Unfortunately, people in Rwanda did believe in the myths, and in 1994 they did rush to bring chaos as the myth predicted. The same beliefs may persist today, and may lead the Rwanda of tomorrow to sink and implode again. Complacent Rwandans will continue to say Rwanda has always been governed by a strongman, and not by strong institutions. At least a few of us students at Mudende Adventist University were able to act in a responsible manner, to demonstrate some faith in the rule of law and in institutions, and in the end to save quite a few lives.

At some point on Friday, April 08, the University administration announced an official closure due to the escalation of violence. The message specified that local students who could go to their respective families or homes were free to do so, but those from Kigali city and other provinces were not encouraged to leave the campus because of extremely uncertain conditions across the country. It was believed that reaching their home provinces would be difficult if not impossible. Only students from the area around Mudende and who needed no transportation were able to go to their homes. No further instructions were given. We students saw evacuation from Mudende as the only option; though we did not know what our fate might be at Gisenyi, we felt we were awaiting imminent death at Mudende. We hoped we would find the government at Gisenyi still in control and able to offer us protection.

Chapter 7

TRADING THE DEVIL YOU KNOW FOR THE ONE YOU DON'T

S ATURDAY APRIL 9TH WAS D-Day and students awoke hopeful that on this day they would finally be able to leave. They had been hiding in houses, on roofs, on shelves, in attics, behind bushes and in cornfields, all over campus, and desperately hoping to escape Mudende. I, too, was looking forward to this day, though I knew we might face all kinds of obstacles and dangers on the road. Death was a real possibility and injury and rape seemed likely if not certain. I had taken to calling the evacuation "the Ship of Hope," and the ship had to sail out of Mudende's cornfields to find a safe harbour in the city of Gisenyi, 35 kilometers away, on the border of the Democratic Republic of the Congo.

We could not know that following our 'ship' would flow a great river of carnage which would flood Goma and then all of Congo with an unimaginable, perpetual genocide, with war crimes and crimes against humanity, and with heartless

plundering of natural resources in Congo, first by Rwanda, and then by Uganda, and then by Burundi, and finally by waves of international criminals. The 1996 Hutu Genocide in Congo by the Tutsi army, far greater in scale than anything that ever happened inside Rwanda, inaugurated a human catastrophe that has been boiling away in Congo for the past 25 years with virtually no international intervention.

At Mudende, I am sure some of the students and staff members who were watching me pushing so hard for evacuation to an uncertain destination, thought me a foolish, self-destructive meddler, while others saw me as a patriot, perhaps even a hero. Perhaps both perspectives have some truth to them. I wanted to communicate to Tutsi and Hutu alike my dream of a country free of hatred, a better Rwanda for generations to come. More than ever it was important to keep upholding those beliefs.

Saturday was a struggle too, and I would have to fight fiercely to save one life among many. I had been touched in childhood by the death of my mother, brother and grandfather, all within 5 years. These losses had sensitized me to others and made me want to protect the lives of those around me.

I had heard there was a conspiracy at Mudende against a girl named Retty. Her life was in imminent danger. I vaguely remembered she had been in one of my courses and I recalled having given her a ride in Kigali a few months earlier, but I hadn't had any contact with her on campus. I didn't know she was a Tutsi; I wouldn't have asked her about her ethnicity. I had myself been harassed and detained in my home province of Ruhengeri in the past few years by Hutu villagers suspicious I might be Tutsi. I was keenly aware of people's obsession with ethnicity.

In Rwanda, when people don't know you very well, many of them speculate about your ethnic background. There are all

sorts of signs that are supposed to indicate whether you are Hutu or Tutsi. Around Mudende, a flat nose, dark skin, dark gums would all be taken as signs of Tutsi ethnicity. In Ruhengeri, my province of origin, people did not say it aloud but the ethnicity seemed to matter less: in my time there, it was more important that you were first from Ruhengeri before becoming anything else. I knew one young female student who was born in Kigali to Hutu parents but had dark gums; she was advised by her friend who hid her not to smile and to keep her mouth closed at all times to avoid being labelled as a Tutsi. Another Hutu girl interviewed on Belgian television described how when RPF soldiers were executing Hutu civilians by firing squad in Kigali province in May-June 1994, she was separated out from the Hutu and placed with the protected Tutsi group because of her light skin and narrow nose. Ethnicity is a contradiction-filled absurdity in Rwandan society, and Rwandans will not have a modern society until they can subdue it.

After the massacres of April 8th, Retty's name had come up in rumours as the most wanted Tutsi girl on the conspirators' short list. She was an imminent candidate for execution. I was well aware of it and very concerned. She was very aware of her own situation, and she also knew I'd been actively protecting students. I was busily preparing for the next day's evacuation when Retty came up to me near the cafeteria to talk with me. Accompanying her was a man I took to be an FAR deserter. He looked disheveled and grubby in his used military uniform, was carrying a light automatic rifle, and was alone, not in the normal group of two or three that was customary for FAR patrols. Retty came up to me, and the deserter stayed well back to let her talk to me.

Retty was in tears and told me the soldier wanted to take her to the girls' dormitory to check her identification. She

said to me in Kinyarwanda: *"Aranyica we!"* meaning 'He will kill me for sure!' and she continued: "He said they told him I have pictures of Fred Rwigema."[16] I asked her if she really had such pictures and she said she did not. I needed to know the real circumstances in order to know how best to help her. She begged that I go with her to her dormitory so that the deserter would not rape and kill her.

At that time, the dormitories were sitting empty, as being there would make it look like you were hiding, and why would you hide, if you were not a Tutsi? Just being there would get you killed, as happened to Janvier, a Hutu who made the mistake of staying in his room where the killing mob found him and killed him immediately. That was why we all stayed out of the dorms and stayed in groups for safety.

I felt I had to help Retty. I confidently walked up to the soldier and offered to go along with them to Retty's dorm. Unexpectedly, he accepted without much hesitation. I had expected he might threaten me, and I wondered if he might have been intimidated by my confidence and insistence on going with them; or perhaps he had some other plan in mind. I suspected he had no ammunition in his assault rifle, being most likely a deserter. I was prepared to defend myself; I would not passively allow a fool like this to gun me down.

When we entered the girls' dormitory, the soldier asked me to stay back from Retty's bunk. I hung back 5 meters and kept

[16] RPF Major-General Fred Rwigema was a Rwandan Tutsi who was the Deputy Chief of Staff of the Ugandan Army from 1986 to 1990. He invaded Rwanda on October 01, 1990 and was killed on the battlefield two days later on October 2nd. Praising or glorifying him as a Tutsi hero was considered treason by the Hutu government in 1990 -1994. Being caught in possession of his picture was a serious criminal offense, resulting either in life imprisonment if not a death sentence.

my eye on him. Retty opened her suitcase so he could search for pictures and ID, but instead, as she told me a few minutes later, he demanded she pay him 5,000 Francs. This would have been two weeks' salary for a teacher in Rwanda at that time, and of course she did not have it.

Retty told me what he had asked for and begged me to pay it and save her life. I had more than that in my wallet, but I didn't trust the soldier at all and pretended to go and look for it in my room. I came back and passed the money to Retty, then immediately went to look for my friend Lieutenant Théophile who was patrolling the huge rural campus to ask him to intervene. He immediately came with me, but when we arrived on the scene the predator had already vanished with the extorted money. He had promised Retty that once he had received his ransom, he would come back to protect her, but that was nothing more than further intimidation. We kept an eye out for him but he never returned. Retty is still alive today with grown up children and a good marriage. I haven't seen her since that day in 1994, but I hear she's doing well.

Lieutenant Théophile warned me to be careful as rumours were circulating that I was a collaborator with the RPF. He knew very well I was not connected to the RPF, and we had always had a friendly and mutually respectful relationship over the years. In any case, Théophile was a professional soldier and made no assumptions about the how and why of President Habyarimana's death. He promised me he would keep monitoring any potential threats to my life. I was very grateful to him; I completely trusted this gracious young man who shared my empathy for all the scapegoats and targeted groups and individuals. He was a soldier with a soul, exactly the kind we needed to save the country from FAR and RPF butchers.

Throughout these terrible days at Mudende, students had been making lists of classmates who were to be killed and

passing the lists to villagers, militia and deserters. I never saw any of those lists, but students claimed to have seen them. I heard at one point that I was on one of the lists, which struck me as ludicrous. A student told me about it and I asked her why on earth my name would be on such a list. Her reply was: *"Because you are saving the Tutsi."* But who was making these lists? How did students get a hold of them? Were individuals or groups doing this? Who were they handing them over to? What motivated them to do all this? I confronted one girl whose father was a former mayor, and I asked her why she was making a death list, and why my name was on it. She told me that my informants were lying, trying to get back at her as they didn't get along. There was no way to extract the truth from all this, but I hoped that talking to her might be a deterrent. Some thought the reports of lists were exaggerated or imagined, but we couldn't assume anything.

I carried on with my role in the planned evacuation. I headed down to the administrative area to check on when the United Nations' convoy was scheduled to arrive to evacuate the foreign students and expatriate faculty and staff to Goma in the Congo. By the time I got there, I was told the convoy had left about two hours earlier, and it had been French troops, not UN Peacekeepers. Given the mass killing that they had witnessed first-hand, I can see why the international faculty and staff wouldn't want our local students' convoy trailing after them on the road. It seemed they just wished to leave us and our spilled African blood on the farm at Mudende, that field of butchery where they would never set foot again. We were young, educated men and women, but we saw ourselves through their eyes and felt shamed, diminished, and barbaric. Just nine months before I had been in France and Belgium; how I wished I had stayed there. What we had just experienced was beyond all reason.

The UN peacekeepers who were supposed to have come to Mudende campus had just been humiliated by the killing of ten Belgian Commandos by FAR soldiers at Kigali Military Camp. I was and am no fan of Brigadier General Roméo Dallaire[17] and his actions in the Rwandan crisis, but I will admit it must have been impossible for him to deal with Hutu extremist Colonel Bagosora on the FAR side and Tutsi extremist Paul Kagame on the RPF side. Dallaire wanted to prevent chaos, but they were both bent on unleashing chaos. They knew how powerless he was on their turf. It was obvious to all Rwandans.

It's easy to see in hindsight that General Dallaire could not have brought these two wily war criminals to the negotiating table without using force, which was not an option for him given the lack of international support. In any case, it appeared that Dallaire had been unduly influenced by the RPF. For those of us looking on, it seemed the RPF maneuvering and deception confused him to the point where he lost control of the situation.

With Bagosora and Kagame fully engaged in agitation and deception, and Dallaire and his peacekeepers stuck in the middle, and with the whole countryside in the hands of crazed militias and village folk, there was no protection coming to students at Mudende. I would like this book to stand as a witness of how the FAR, the RPF and the UN peacekeeping forces were all completely devoid of creativity and altruism, and how they completely failed to fulfill their obligations. Rwandans

[17] Brigadier General Roméo Dallaire knew that his 10 UN peacekeepers were detained at the Kigali military base, just 50 meters from the High Military Academy, ESM, where he was attending a meeting with the Rwandan Hutu military high command on April 07, 1994 at 10:00 am. He did not do much or enough to intervene and save his men either before or during this meeting. He left the meeting without knowing their fate.

will live with the impact of these failures for generations. We were disappointed to be excluded from the escorted evacuation, but we were determined that our own convoy should succeed.

I went to find a professor, the library director, to see if he had the keys for our three promised vehicles, and he was able to find them for me. I was eager to get rolling. Now that I had my hands on the keys for the bus, the minivan, and the pickup truck, I felt ready for action.

Knowing that there would be Tutsi students with the convoy, the library director was very concerned about our safety. He asked me if I was sure we'd be okay. I knew there was no guarantee, but I reassured him we would be all right. We had to act and think positively if we were to have any hope of a positive outcome. To evacuate those lives only to perish with them in a ditch was not on my list of possible outcomes. My principle has always been to choose the lesser of two evils. Rather than leave Hutu and Tutsi students to be butchered at Mudende, we would publicly put them in the hands of the local government in Gisenyi. That would force the government to take responsibility.

I understood that the library director's query was a personal one as well as one of general concern; his brother and sister-in-law would also be in our convoy. He seemed convinced that this was their best option, and he showed that he trusted me to handle it, which I appreciated very much. We both knew how dangerous it was to stay at Mudende and how volatile the surrounding area had become. We knew very well there would be danger on the journey from the Hutu villagers and militia at the campus entrance and from the notorious militia leader Vedaste Kidumu as we passed through the Nyundo area. Kidumu, in my opinion, was an illiterate hooligan whom I had come to know as a persistent and chronic offender during my six

years at the Seconday School in Nyundo, and he had become a ruthless and prolific killer for the Social Democratic Party, PSD.

Encouraged by the library director's expression of confidence, I took my precious vehicle keys, which I clung to like a good luck charm, and joined the students on the main campus to organize the evacuation. The library director's help continued to be critical; he was the only administrator available for support and encouragement.

I asked students to get their belongings together right away, though we had the whole afternoon. We were about to start an organizing meeting, when suddenly we saw a red pickup truck coming from the south side of the university corn plantation along a narrow track. The truck pulled up to our large group and out leaped the notorious Kangura journalist, Hassan Ngeze,[18] with an Uzi cradled in his arms. A businessman from Gisenyi who I recognized jumped down from the other side. Ngeze struck a Rambo pose clearly intended to intimidate us. I had crossed his path a number of times at National Television in Kigali and knew he would recognize me. I thought it was possible he'd heard I was saving Tutsi and that he and his crony had come to kill me. I walked towards them and tried to stay calm so the other students wouldn't be panicked by their sudden appearance and Ngeze's menacing posturing.

I was about to ask him why he'd come to Mudende, and then give him an explanation of what was going on that might appease him, but as soon as he set eyes on me, he yelled: *"Eeh! Television guy! What are you doing here?"* That dispelled my

[18] Hassan Ngeze was a Hutu Rwandan best known for spreading anti-Tutsi and pro-Hutu-Power propaganda in his Kangura newspaper between 1990 and 1994. His aim was to counter-attack the Kanguka newspaper held by the Tutsi and other media including the RPF-Muhabura Radio which promoted pro-Tutsi extremist ideology while being anti-Hutu.

paranoid thoughts and spared me from wetting myself as I'd been on the verge of doing. Now I knew he wasn't looking for me, and I asked him why he had come to Mudende. As it turned out, he was driving the businessman who had come to evacuate his daughter, as he was authorized to move freely during the curfew hours at Gisenyi.

Knowing the pseudo-journalist Ngeze to be an insecure individual, I was not surprised to see him trying to be intimidating. He exuded bravado and was very touchy, so I knew if we rubbed him the wrong way the consequences could be fatal. Finally, the girl they'd come to pick up was located among the crowd. They threw in her luggage, she got in and they drove off the same way they'd come. I felt we'd dodged a bullet and was thankful they were in and out so fast. Everyone who knew Ngeze's reputation was relieved. In Rwanda in 1994, he was worshipped by militiamen, peasants, some politicians, and even some FAR soldiers, though generally the professional military and their civilian analysts were not in favour of collaborating with the untrained and undisciplined militias with whom Ngeze aligned himself. He was undoubtedly more powerful than either Gisenyi's Governor or army commander Colonel Nsengiyumva. We had been lucky to see him come and go so quickly.

Now as we prepared to set out, I made sure my fellow students knew that we were going to be evacuating ourselves, as all of the Mudende administrators had left with a convoy of French troops sent by the UN Peacekeeping force. The most dangerous part of our journey was right at Mudende University and the surrounding area, where people had been keeping us under surveillance. I now understood that through their campus jobs, proximity to students and opportunities for friendly conversation, the villagers knew exactly where individual students could be found and what their routines

were. But we knew the villagers' routines as well; in that rural area, they would typically be in bed not much after five in the afternoon, which gave us a good window for our escape at around 9:00 p.m. that evening.

There were over 600 students who wanted to leave the university with that first trip, so we had to come up with some principle by which to decide who to evacuate first. A large number of students were insisting on going with the first convoy, but the priority was obvious; the Tutsi, whose neck veins were swollen as big as oil pipelines from their days of absolute terror, would be the first to go.

Some of the Hutu students now opted to walk the 35 kilometers to Gisenyi, feeling it was hazardous to their safety to travel in a vehicle with Tutsi aboard. They would take a shortcut through the countryside. Their decision was fine with the rest of us as it made it easier to give precedence to the Tutsi evacuees. It was also good for us to avoid their negative comments and conspiratorial whispering. There was no room for anything but positive energy. But most of the Hutu students were not like this; they volunteered to wait for the second, third, or fourth promised trips between Sunday and Monday. I think they trusted me to keep my promise to evacuate everybody no matter what. I was determined to show that my promise was more than just words.

We now urgently needed two more drivers. I had assigned myself to drive the bus and asked for volunteers to drive the minivan and the pickup. Even though there were almost 1,000 unmarried students at Mudende University, it turned out that only three had driver's licenses in addition to me: John, Eugene, and another who was not available. Even worse, Eugene, who was only 19, was too scared to get behind the wheel, still traumatized by the violence and bloodshed he had witnessed.

John seemed like a solid and confident guy and he volunteered to take the minivan. We went back to the students again and found one with a learner's license who said he could handle driving the pickup truck. I was hesitant but other students yelled that he knew how to drive. I decided not to worry about it; if he could start the car, the rest would be up to God. Even though I would feel somewhat responsible if he got in an accident I knew we didn't have much choice.

We were as ready as we could be. The student committee that had been formed days before had pretty well evaporated. We were tired and nervous, and at dinner hour no one who was going on the first convoy had any appetite. Some Congolese students were still with us, and I vaguely wondered why they had not been evacuated with the UN peacekeepers earlier, especially as the destination of that convoy was Goma in their own country. It was puzzling that they were also expatriates but did not get the same treatment as the others. In lieu of eating, we rushed about gathering up suitcases, bags, sacks, blankets, toiletries and anything we could easily carry – we were still expecting to come back in a few days when things settled down. We were so focused on our academic lives, so obsessed with studying and competing for grades that it was hard for us to accept that our lives had now been completely derailed. We weren't really paying much attention to material things anyway, as we were all worried about family and friends we had not been able to contact. And above all, we were so anxious that many refused to eat for fear of losing their place in one of the vehicles.

Now, 25 years later, when I look back at what happened to us in those early days of April, I have a new appreciation for what the Tutsi must have experienced in the Ugandan refugee camps. For 30 years they had been denied the privileges we took for granted at Mudende. It is not surprising that the RPF wrested power from the Hutu elite and handed our privileges

back to their own Tutsi people, turning Hutu once more into second-class citizens as they remain today. Power and privilege have flipped back and forth between Tutsi and Hutu through a series of political conflicts: the 1959 'social' revolution; the 1973 coup d'état, and the 1994 'liberation' war. These reversals have been the product of poor political decisions and narcissistic leaders, locking Rwanda into a pattern of ethnic conflict that is inimical to progress.

Our three vehicles could take no more than 300 students even if we packed them as tight as bees in a hive. Students had now lined up and were boarding all three vehicles. Suddenly, two male students who had been hiding somewhere came running flat out and burst through the queue into the bus. They had no belongings with them at all. I could see some of the students wanted to throw them off the bus, but I urged and begged people in the back of the bus to squeeze them in. Who knew what pressures they had been under? Other students, Hutu and Tutsi, came out of hiding only at the last minute; we gave them priority in the minivan, as that was easiest. And finally, we were ready to embark on our uncertain journey.

Earlier, before we had boarded, some students had warned me that those wanting to kill us were waiting at the university gate. To prevent us being stopped and blown up by peasants and militia at that entrance, Lieutenant Théophile and his squad escorted us out, with their white pickup leading the way. Sure enough, at the university gate, he had to warn a few villagers who had been waiting to stop our convoy to stay away from our vehicles. After we were well off the campus, we stopped and the Lieutenant came over to wish me good luck on the road. He and his squad would remain at Mudende University to assure the security of the students and staff members who were still there waiting for us to come back for them the next day. I was determined that we would be there for them.

Mudende's Gate

Crossing the gate at Mudende was, in our minds, beating death the first time; now there remained seven more roadblocks, each a potential deathtrap. The Lieutenant had told me that there weren't many roadblocks on our route, but I took this as a friendly attempt at reassurance and not a real assessment of the danger. I kept calm and drove slowly, continually checking the progress of the two vehicles behind me in my mirrors. We drove with no headlights so as to avoid attention, and as slowly as a funeral procession. That turned out to be the right strategy.

It was an incredible experience. It became clear to me that when death crosses your path on a journey, every second of life after that is an extraordinary blessing. Despite my gratitude that I was still alive, it is impossible for me to describe the painful turmoil going on in my head as I led the convoy through that night.

Kabali Roadblock

We drove carefully on the seven-kilometer unpaved country road to Kabali, a cattle market on the highway from Kigali city to Gisenyi. To get onto the highway, we had to pass through a roadblock manned by local peasants. I opened the window and greeted them with great enthusiasm: "Hey, *benewacu*[19]. You are doing a fantastic job for our security! I am following the White pastors from Mudende University that passed by here earlier on their way to Gisenyi town." These gentlemen replied, "*Nda kibazo. Ngaho ihute.*" *Oh! No problem, just hurry up then.* I smiled and thanked them and drove on up the hill, turning right onto the highway, headed for Gisenyi.

[19] Fellows or guys in Kinyarwanda

Once on the highway, I continued to drive slowly to make sure the two young drivers would have no safety issues and could follow the bus comfortably. I turned on the headlights and the others followed suit to ensure we would be inconspicuous on the highway. I knew that the locals wouldn't pay attention to every single car that drove by. The ease with which we'd passed the Kabali roadblock suggested to me that the villagers on the barricade didn't know what had happened at Mudende University. I expected the next roadblock to be similar, but I didn't allow myself to get too complacent.

Nyakiriba roadblock

The road around Nyakiriba was dangerous for new drivers, weaving in and out through the steep mountains. It was particularly challenging for a heavily overloaded bus with almost 200 passengers. I was also worried about John and Edison. I knew the road and the area as I'd passed through there dozens of times during my six years as a secondary school student in nearby Nyundo. The village of Nyakiriba was in the midst of a huge banana plantation; the roadblock was in an eerie and strange-looking spot, and I also knew it was very near the home of Hutu RPF Colonel Stanislas Biseruka, which was not good news; we could expect to be questioned. I was nervous, but as we came up to the roadblock, I hoped for the best.

As I looked around, I saw a young man coming towards my bus. Before he could say anything, I told him he looked a lot like my former high school teacher, JPS. The young man's face lit up and he confirmed that JPS was his uncle. I had visited his uncle here once and I had some connections I could capitalize on. I asked him whether another Nyundo elementary school

teacher named Célestin Setako[20] was still playing football and he asked, "How do you know everyone around here?" I answered, "I'm from around here too." Satisfied that we were connected, he rushed to raise the long bamboo barrier without paying any attention whatsoever to my passengers. As we drove through, I knew that at each of these roadblocks any suspicion or challenge might lead to a bloodbath, and driving out of Nyakiriba, I said to myself that I had just escaped death for the third time in half an hour.

The football player and teacher, Célestin, whose men's team used to compete against my high school team when I was a student at Nyundo, later became the RPF Mayor of the District of Kanama. He was cruelly executed without any form of trial by RPF soldiers the following year, along with 110 blameless Hutu peasants, the same way a hundred innocent Tutsi peasants had been slaughtered at Mudende University on April 8th, 1994. The Tutsi and Hutu regimes have been equally talented at slaughter and war crimes. I have to feel sorry for all of us Rwandans. A life of happiness is not written in our stars.

Mahoko Deadly Roadblock

The next roadblock, at Mahoko, was a different story altogether. The memory of it always brings a cold chill down my spine. In hindsight, it was a miracle our student convoy managed to pass through it without bloodshed. Not long after our convoy had passed, Mahoko Barrier became a human slaughterhouse. Hutu moderates--and of course, Tutsi of any

[20] Celestin Setako enrolled at the Butare Non-Commissioned Officers Academy but was barred from a military career due to having a foot deformity. He was born to an impoverished single mother, and his promotion to RPF Mayor made me very proud of him. In my view, he never had a decent shot at life under either the Hutu dictatorship or the Tutsi tyranny.

stripe--would be murdered savagely at this graveyard barrier without any due process of law. Here would die the former Director of Immigration and Citizenship, Emmanuel Nzitonda, a Hutu who had grown up at Mahoko and had gone to Nyundo Junior Seminary School. He, his Tutsi wife and their two children were fleeing from Kigali where FAR and RPF were engaged in intense combat.

My former manager at the National Scholar Printing House, Hutu moderate Stanislas Sinibagiwe, and his wife, also a Hutu, met their end there, too. Later on, Hutu from the northern provinces took a different route to Congo, DRC, travelling on foot for 300 kilometers through southern Rwanda rather than driving the150 kilometer route via the northern highway, because for just about everyone, Mahoko had become a graveyard.

Many Tutsi and Hutu from all over Rwanda decided to remain in Kigali, but they fared no better there than on the road; they were tortured and butchered first by the FAR who were losing the battle and looting the city, and then by the RPF as they seized the capital. That our student convoy was able to cross the fatal barrier at Mahoko without loss of life wasn't because of superhuman or heroic efforts on our part --it was either blind luck, fortunate timing, or divine intervention that our Ship of Hope did not sink there and then.

By the time we arrived at Mahoko, it was around 10:00 p.m. and completely dark; there were no other cars on the road because of the curfew. I looked around but there was no one manning the barrier. Knowing the area and its Butunda banana beer very well, I assumed the guards were off drinking themselves into a stupor. I called over a young teenager who was hanging around near the barrier and asked him if he could open it for us. I looked down pretending to be busily reading something, thinking it was best to say as little as possible. As

he opened the gate, I smiled and told him to tell the guards we were from Mudende University and on our way to Gisenyi. This statement was rather meaningless but might reassure the guards and dissuade them from following the convoy when they got back; and it might be helpful in establishing my identity when I went back the next day on my way back to Mudende University.

I didn't really have much choice. I needed to give the impression that our vehicles had only Hutu students aboard. If it were known who was really aboard, I could easily be killed as a traitor. I had no desire to dig my own grave. The two cars behind my bus followed right on my tail as I jubilantly drove on. What a night!

I was concerned they might follow us, but I couldn't really think why they would do so. In retrospect, the reason why we managed to cross Mahoko without incident may have been that the reaction to President Habyarimana's death was just building, and the violence had not yet spread to the streets because of the curfew. This area was remote from Kigali, and few FAR or militia would have made their way here this early in the war. At this point, they were occupied with their diatribes against the RPF and their tales of the harrying retreat from the capital. The RPF and FAR's mortar explosions, katyusha rockets, and the marauding and wounded army deserters had not yet reached Mahoko to help build the locals into a rage. The FAR would need to lose more battles and the Hutu Power government would have to sense it was losing its grip before widespread resentment towards the Tutsi would turn from a trickle to a torrent.

Sometime after this in May 1994, I remember running into a former high school acquaintance, a FAR junior officer, while visiting my wounded cousin, a corporal in the gendarmes, at the Gisenyi Hospital. The officer had been seriously wounded.

When I went over to see him he had nothing good to say to me, and accused me of avoiding signing up for the army because I had known that the RPF were going to invade Rwanda. I understood how he saw me, standing there peacefully and all in one piece, while he had serious wounds inflicted while fighting under our country's flag. I felt empathetic toward him, and toward all my many relatives and classmates wounded and killed during the 1990 -1994 Rwandan civil war and the 1996 war in Congo. May their souls rest in peace. They loved our country and they died for the nation. I didn't feel guilty before that wounded officer, though; I was also in combat to save the nation, but on a different front. In the end, we both lost the nation and people whom we loved. We were both so proud of Rwanda, our lost paradise, that we would not have missed any opportunity to make a contribution.

We were on the road again, two miles out from the Mahoko barrier. As we drove down the hill near Sebeya Waterfall, the minivan trailer detached from the van and rolled along on its own trajectory, with twenty students in it screaming at the top of their lungs in a way guaranteed to bring attention to us if they did not stop. John, the driver, didn't notice what had happened until students in the back of my bus yelled out the windows and let both John and me know what was happening. The trailer kept rolling behind us for a while and then veered off into a banana plantation beside the road.

I stopped the bus and jumped out to help John. He backed up and we re-attached the trailer, with the students from the pickup truck running up to help. This dangerous area was the last place we wanted a circus like this! We resumed our painful journey driving even slower than before. We could not afford any more incidents that might attract villagers or militia. We all tried to minimize the risks and we succeeded pretty well, but we knew how terribly wrong things could go at any moment.

Nyundo Roadblock

The next roadblock was at Nyundo, just across from the Ecole d'Arts, where I had spent six years at the boarding school. I had been well-known locally as a soccer player during my high school years, and was so well connected with the local inhabitants that I couldn't help but be recognized. When we rolled up to the barricade, I was received by cheers and greetings, hugs and laughs; the students on the convoy were so pleased at this welcome that they forgot about death and danger for a while. I knew I wouldn't have to explain anything here. Feeling very comforted, we returned to our uncertain voyage. We couldn't carry the relief and excitement past the outskirts of Nyundo, and I told the passengers on the bus to quiet down, pray and stay strong. Many of the students were still teenagers and they didn't have a realistic sense of the danger they were in. We were now in real danger, for we were in the territory of the most notorious militia leader and mass murderer in Gisenyi Province, Vedaste Kidumu. If we had fallen into his hands, our journey would have ended with none living to tell the story. I had known Kidumu during my secondary school years at Nyundo. After the 1991 democratization and introduction of a multiparty system, he rose through the ranks of the Social Democrat Party. It was our very good fortune that he was not in the Nyundo area when we passed through.

Rugerero Roadblock

The roadblock at Rugerero was right across from the houses of two former schoolmates of mine, Irene and Noel. I planned to start the conversation at the barricade by asking after them. As I came up the barrier, I saw a man I knew well, Emmanuel M., in his cowboy hat, walking towards his house. I had given him a ride a couple of months earlier, from my uncle's home at

the Gisenyi prosecutor's office to his home here in Rugerero. Emmanuel had retired long ago from the military and had become an electrician. He was pretty much drunk all the time, and that night was no exception. The guard from the roadblock walked over to us to ask about the bus, but instead of answering his questions, I distracted him by asking him to call Emmanuel to come back and talk to me, which he did.

As soon as Emmanuel saw me he greeted me very warmly and insisted I come over to visit with him and his family, but I begged off, promising to swing by and see them the next day on my way back to Mudende. Seeing me engaged in this conversation, the barrier guards had already opened the gate for our three vehicles. They could see all of us were students. The journey was a surrealistic alternation between painful, scary moments, and then pleasant social conversations. I remained very cautious and I was very clear about what could happen ahead. Having just witnessed the bloodbath at Mudende University a few days before, I knew that the next roadblock at Gihira, could well be another brush with death.

Gihira Checkpoint

Gendarmes, the national police force, looked after Gihira checkpoint. This check point was not so much to stop vehicles but to make sure the Gihira Hydro Station was protected against artillery or explosions from any military enemy force. This Hydro Central station served the city of Gisenyi, the surrounding factories, and a number of public and private corporations. These gendarmes were professionals, asking only who I was, who the passengers were in the three vehicles, what goods we were carrying and our purpose in Gisenyi. After I showed them my National Television card and student card, they did a fast-visual check of the three vehicles through the

windows and told me to continue. I fired up the engine and headed off for Gisenyi city 4 kilometers ahead.

Gisenyi City Gateway

At about 11:00 that evening, we finally arrived at the Gisenyi city gate, a roadblock guarded only by a couple of FAR soldiers. This was the only way in and out of the city, except for the border crossing to Goma in Congo. More than a thousand Mudende students were to exit through Goma, most to later meet their deaths and some to go into a long exile that still has not ended. And now we entered Gisenyi, a gated city under the huge mountain called Rubavu.

I knew Gisenyi very well. I had played many soccer games there during my high school years, and trained with a Gisenyi junior team as well. My younger brother taught high school in Gisenyi and my uncle was a public prosecutor there; the city was filled with my extended relatives, friends, and acquaintances. I loved the lake and beach; Gisenyi was a beautiful place, in stark contrast to the squalid town of Goma just across the border in the much more prosperous Congo.

I used my connections and knowledge of Gisenyi to try to convince the young FAR soldiers at the city gate to let me continue on to the administrative centre where high-ranked civil servants lived, and where public and private 4-star hotels lined the beautiful beach. It was now around 11 p.m., the area was under curfew, and at this hour no entry was permitted. I explained to the FAR soldiers that we were university students evacuating from Mudende campus. I felt the conversation was going pretty well, but just then my fellow student driver John whispered in French," *Dis leur, nous allons à l'hôtel*" and then to my shock and surprise went on angrily in Kinyarwanda, "*Ibi bicucu ra!*" which means "*What idiots!*" I was completely taken

aback, and struggled with anger at how he had just put us in jeopardy.

I had talked my way through seven consecutive roadblocks with disastrous consequences facing us at each one, and now this student from my home province was putting everything at risk. He was close to my own age, we had both studied overseas, and he had shown leadership skills in the evacuation, which I had appreciated. However, he hadn't mastered the skills of diplomacy required at this delicate and dangerous point in our journey. I politely invited him to go back to his minivan, start his engine and get ready to continue on to the office of the Governor of Gisenyi Province before John managed to sink the Ship of Hope altogether. I silently thanked my old high school psychology teacher Anastase for his advice: never respond to anger with anger. The gendarmes asked me if my fellow student was insulting them, and I quickly assured them that he was just a bit unhinged since the President, who was his uncle, had been killed. This was a lot of nonsense, but it was a positive message for them, and they responded saying they, too, were very affected by Habyarimana's death. I told them I would be seeing them the next day as I passed by for the next evacuation from Mudende. It was critical to establish a good relationship with them; I had to do this consistently with the people on all the roadblocks. John vanished after this first trip, which was probably all for the best. He had shown that he was unable to keep a low and innocuous profile, which undermined my efforts and risked our safety.

We reached the Governor's office, the end of this leg of our voyage, around half past 11:00 pm. I expected we'd find a retired soldier there, sleeping in a sentry box, and that was exactly what we found. I was used to seeing sentries sleeping in the same boxes everywhere in Rwanda.

We parked in the Prefecture parking lot and I asked everyone to get out for a bathroom break, and to stretch and to wake themselves up. I went up to the sentry box and called out to the sleeping guard; he woke up startled at the presence of the bus and started shouting at us. I told him we were university students but he was unimpressed and told us the Governor was sleeping. He ordered us off the lot and told us we could only park on the street. I could see there was no use in arguing, and we moved to the street along the beach. This turned out to be a much more pleasant spot, and the fresh air from the lake helped revive the students after their crowded, uncomfortable journey.

I was pretty sure that the Governor would not be there. Given the massacres and general chaos erupting after the death of the President I expected him and his entourage to be travelling as needed through the country. As it turned out, I was quite wrong; all the officials were sleeping in their own beds as usual. I found that hard to understand.

At this point it seemed prudent to John, Francis and me to try to persuade the Meridian Hotel manager to let us camp on the hotel property. We roused the students, many of whom had fallen asleep, and all of whom were tired and fearful. There were almost 300 of us. I told them we were going to try to get permission to stay on the Hotel's grounds for the night, just so that they would know what was going on and not feel out of the loop. I also wanted to keep communications open to indemnify myself against any accusations that I'd delivered students into the hands of the militia, should we end up in that kind of trouble. In Rwanda, people are always alert to the possibility of being manipulated and betrayed.

The Meridian is a five-star hotel right on Gisenyi's beautiful beach. I had never stayed there, but I had eaten there quite often when I was covering a presidential summit three years earlier. I had a good sense of what the hotel management was

like, and I knew I would have to approach them with a good deal of diplomacy. I told the students my reasoning was that the Hotel was a government entity as was Mudende University, and I couldn't see another way to protect us from local authorities who might harass us during the night. I wanted to ensure that we were under some form of official protection. The confused military committee or "junta" had appointed Jean Kambanda as interim Prime Minister, and Dr. Théodore Sindikubwabo as interim President, but the country was in a vacuum of leadership. We had no notion about what was going on in the capital.

John, Francis and I went to the reception desk at the Meridian and through good luck were able to speak with the manager immediately. I explained the situation and I asked him to let us camp on their grounds, given that his hotel was a governmental enterprise and we were governmental students. He clearly understood our circumstances, but he categorically refused. John threatened to call the Governor, and once again I asked him to just keep quiet.

In addition, I remembered clearly my uncle's story of his bad experience in that Hotel. After a few beers, he had begun to argue with President Habyarimana's pilot, the late Major Ntuyahaga, having no idea the President himself was there. Habyarimana himself had come upon this scene, witnessed the confrontation, and asked the manager to intervene with my drunken uncle. My uncle had apologized, and though he knew the manager well, and the manager knew him as a prominent local person, he had never gone back. So I guessed now that some VIP might be staying there[21], and that might be the reason

[21] I learned later that an important Rwandan delegation, including the chief of civilian intelligence services, Dr. Agustin Iyamuremye, had been staying there that night, waiting for a helicopter to take them to Gitarama Province.

for the manager's refusal. Or perhaps I just hadn't asked the right way.

Now I took a different approach and asked the manager if he could put us in touch with some authority that might be able to assist us so we could vacate his parking lot. It's very effective in Rwanda to act as a suppliant, and make a request in a way that makes the other person feel they have power and can do you a favour. If you try to force the person's hand, you will hit a wall, because wanting to be seen as a big man is a powerful need for many Rwandans. The Hotel manager now felt flattered and important, and he called up the Gisenyi Gendarmerie Base Commandant, who dispatched a Lieutenant and two guards to take care of us. They were there within 5 minutes!

The Lieutenant first talked with the manager, and then came back to us to say that there were some VIPs in transit from Kinshasa staying at the hotel, waiting for a helicopter to take them to Kigali, which was why the Meridian had to keep their grounds clear for security reasons. He offered to escort us instead to the Umuganda soccer stadium, and we gladly accepted that offer. Now we were under the protection of the national Gendarmerie, which was very reassuring. No one had any security after President Habyarimana's death, certainly not a group of university kids travelling across the country on an ad hoc evacuation to nowhere. Civilians were being killed by both FAR and RPF in Kigali, where intense combat had resumed April 7th. There was not much for us to do except hope for a miracle.

The Umuganda Football Stadium was about 4 kilometers from the Meridian Hotel and we arrived there at midnight. I talked to Lieutenant Kanzeguhera about Mudende and mentioned his colleague Lieutenant Théophile; he told me he was very aware of what had transpired at the University. I asked if he could post any men to look after our security for the night,

which he promised to do. And indeed, students came to me a bit later and reported that there were armed men patrolling the perimeter of the stadium. I felt very reassured; the Rwandan Government was now responsible for our safety. I felt that the pressure was off for the moment, and the students seemed relieved as well.

Driving to Umuganda Stadium, I felt relaxed and the students were happy and joking that we were very important now as we once again had a Gendarmerie escort and guards. Thinking about what they'd been through, they kept giving each other big hugs, smiling and grinning. People close to me were giving me backslaps and friendly punches, pulling my leather jacket and grabbing the steering wheel. The Ship of Hope had not sunk. We felt infinitely more secure than we had the last 5 days at Mudende.

I now realized I desperately needed a blanket for sleeping and had not brought one, but I immediately had offers of blankets from a dozen students. The solidarity in the group had come a long way. Umuganda Football Stadium was very familiar to me; I had watched and played soccer there for years, and participated in rallies for President Habyarimana there during the era of the one-party state under the MRND. This stadium has a covered area much like any Western football stadium. We slept; those who had no blankets huddled with others for warmth. There was real solidarity among the group and everyone helped everyone. We were in a very good place. We didn't have any trouble with list-makers there at the stadium. We were safe.

But this was an open stadium and from time to time we heard piercing screams in the surrounding neighborhoods. The sounds suggested that someone, a Tutsi or a Hutu, was being tracked down and killed. The night was incredibly quiet for a city where life, cars, and markets normally ran 24 hours a day. Even a complete newcomer to the city could have sensed

that something was very wrong. But at that moment I wasn't thinking about the bigger context or the future; I had completed the first stage of my evacuation mission. I felt that somehow the next trip to and from Mudende would be easier than this day had been.

We woke up at dawn with the first coloured bands of the sunrise low in the sky. Usually in a town like Gisenyi, roosters serve as alarm clocks for the people, but now even they were silent. It seemed that they, too, were traumatized by what they instinctively knew was going on around them. For students, there was no breakfast on this day, but they seemed to cope well with that. Students were wondering what to do as the day went on. With the curfew, restaurants were staying closed and I couldn't drive there as some were requesting. Markets were closed and after four days of this, people who depended on daily buying and selling for their food were already beginning to starve inside their houses.

We went round and round in circles trying to figure out our next steps. We finally decided the best course of action was to go back to the Governor's office. We were hoping that having a number of students waiting out in front of the Governor's office would get his attention and get us some assistance. We assumed that he would be at his office frequently in the current state of emergency.

I asked that the majority of the students wait at the stadium until I had evacuated everyone remaining at Mudende. We had a fairly secure place to stay there. In the meantime, I drove four students to wait for the Governor at his office and present our case to him when he got back. We also asked students from Gisenyi to act as guides and connect us with people. I promised them we would have another meeting when I got back from Mudende.

John and Edison had said they would come with me to evacuate all the rest of the students in one more convoy. They told me they first wanted to go and see their families in Gisenyi and that they would meet up with me at Mudende. I would never see them again. I learned later that they had hung onto the vehicles they'd been driving for several more days for their own personal use, cruising around the town after curfew, and then handed them over to the Adventist church in Gisenyi and went off to stay with their families.

Their disappearance didn't surprise me and didn't really make much difference. I have to say that after John's departure it felt good to be in control and able to make decisions on my own. I headed back to Mudende the next day, 35 kilometers away. I loaded the bus with more students and a few staff, and came back through all seven roadblocks, again without incident. The guards were now used to me, and I had begun greasing their palms with 100 Franc notes. If the Hutu government had not collapsed, I would have billed a government ministry for these expenses, but within three months they had all become beggars in Kenya, Congo and elsewhere, so I haven't recovered anything yet.

Coming back from Mudende the second time, I drove back to the Governor's office to pick up students from the first convoy who had been waiting impatiently there for an audience with the Governor. I drove everyone over to Umuganda Stadium. As soon as I had dropped off the second load of students, I was off to Mudende to pick up the next group of students and staff. Each trip seemed easier than the last, and I felt so positive that I lost any real perspective on the dangers we were facing.

I arrived back at the stadium on that Sunday afternoon with the third busload of student evacuees. Students back at the stadium had been waiting to tell me that the Lieutenant gendarme in charge of our security had told them that we

were to be transferred to St. Fidèle College. I also learned that Lieutenant Théophile, who had remained at Mudende, had found out that there were very few students and staff members who wished to stay at the university; he evacuated some of the few remaining students in his pickup truck and came back to Gisenyi to be reassigned to other duties.

For security and safety reasons, the Gisenyi Gendarmerie Commander had decided to evacuate students from the stadium to St. Fidèle College as the latter had enough dormitories to house the Mudende students. I called on all students to discuss the situation and make appropriate decisions. I told them I thought moving to the college was their best option, given that the stadium was a very public place accessible by anyone. Given that the authorities now knew us and we were formally under their protection, it seemed prudent to follow their direction. I also suggested that students from Gisenyi with friends and family in this city might want to think about hosting and hiding those who were most vulnerable, since the college, too, would be a public place, and not fully secure.

It was commendable that the students very generously helped one another, and those who could stay with relatives or friends took at least two others with them. Claudine Singaye took almost a dozen girls home with her; they remember and appreciate her generosity even today. Others banded together in groups of five or ten to make themselves less vulnerable. In hindsight it's worrisome to think about how many in these groups were relatively defenseless young women. I often wonder what became of them.

As time went on, many students learned that their families had not fared well while they were separated from them. I particularly remember a pair of Hutu sisters, Add and Kay Ndagijimana, who hoped that their family had been evacuated by the RPF. They later discovered that their family had been

annihilated by the same RPF. So many students lived with this kind of uncertainty, this level of violence. What kind of country did we grow up in?

My final announcement was to invite everyone to assemble on Monday at the Governor's office to press him to find buses to drive students from the southern provinces to their homes. I offered to drive some of them with the University bus on condition that the Governor's office provide me with military escorts. When I look back at the ideas and initiatives I proposed, I see that I must have sounded like a naïve, would-be guardian angel. Between bus journeys, I even busily matched up students with my relatives in town. But those were my family's values and habits; I couldn't really have done anything differently.

The two Sunday expeditions to Mudende had gone well and without incident, and I was looking forward to continuing the evacuation on Monday, April, 11th. But as we all have heard so many times, every day is not Sunday.

Chapter 8

MONDAY, APRIL 11: LAST TRIP TO MUDENDE

BACK AT THE GISENYI Governor's office, the students had been granted a meeting with the Governor's assistant while I again made the journey to and from Mudende. Upon my return, I learned he had promised to find some buses within a couple of days, and had urged the students to wait calmly and patiently at St. Fidèle College or with their host families. In two days students from the south were to be given a bus to get back to their respective homes, though a few decided to stay in Gisenyi because it was not safe in their regions. I was still committed to finishing the Mudende University evacuation. The fourth and final trip was to be a near-disaster, and on that day I would learn some hard lessons that would change me forever.

At 10:00 am on April 11th, I headed back to Mudende to evacuate more students, staff members, and Congolese expatriates. There were about 150 remaining students in total,

and I was determined to save the lives of Tutsi, Hutu or anyone who needed to flee Mudende. My two co-drivers had vanished after the first trip and I pushed myself to keep going. We had successfully evacuated many students, and now the villagers in the surrounding area and the militia were starting to harass staff and professors from southern Rwanda. It had brought me great happiness to have successfully evacuated hundreds of students, including some of the most vulnerable. I had promised those who remained that I would come back to evacuate the remaining students and staff. I was sure that I could keep going until all of them were out. I was feeling very confident and up-beat that day as I headed out for Mudende with the goal in mind of taking out the remaining students who wanted to leave.

The drive to the University was an uneventful 45 minutes on a perfect sunny day, and my mood started out sunny too, but my first passengers' faces were dark and fearful. I could well imagine what they had been living through. I planned to drive around the usual loop past the northern men's dormitory, the cafeteria and the women's dormitory and along the administrative residences, then turn around and finally pick up students and staff on the next street before exiting through the main campus gate.

I started by picking up Rwandan and Congolese students at the northern dormitory. As I continued on my route, a Congolese staff member, Maheshi, and another lady signalled frantically for me to pick them up. They quickly got on and asked me to turn left and pick up other staff members on the other side right away: "Please hurry, they're going to kill them." They gestured to get me to turn around and drive to the Northeast Gate. They told me that "killers are looking for him." "Who?" "Just goooo!" They directed me to where Côme, his family and a few students would be waiting. I did as they said without questioning. But they had not told me what

had been going on the campus that morning: a mob had been hunting Côme's family.

I drove fast to get where they pointed and found a nightmarish scene. A dozen villagers and militiamen were running in all directions. Some had managed to get to Côme, his wife and two toddlers who were standing on the street with their belongings. Among the runners was a FAR soldier carrying an automatic rifle. I jammed on the brakes to get the family on board, not knowing the killers were looking for my head as well. On the street stood Côme, his wife and two handsome children, dressed in little black suits and ties. I was still unaware that almost twenty villagers were running after the bus and that I was one of their targets.

As I shut off the engine, villagers began hitting the sides of the bus with their hard, rough hands, shouting at me to stop and calling me foul names. In a fraction of second, they had Côme's wife's clothes off and they proceeded to cut her to pieces with machetes, and to kill Côme the same way. I was in shock and closed my eyes so as not to see this horror. As the two little children asked their dying mother what was going on, the villagers finished them off with clubs. I hid my face in my hands; the students on the bus were screaming: *"Ohh, bagiye kubica... Oh, mama weee...ooo. Barabishe...Hummmm.[22]"* Those who had been standing beside the murdered family were weeping and dazed.

Suddenly, an enraged soldier stormed onto the bus with two wild-eyed villagers who pointed at two of the students among the many Tutsi and Hutu aboard: Byamungu, a Tutsi, from the DRC, and another man I recognized but didn't know. I imagine the villagers had been watching these students, waiting

[22] *"Ohh, they are going to kill them...Oh, my god...oooo. They are killing them...Gosh...Hummmm!"*

for them to come out of hiding and get on the bus. The thugs demanded their identity cards. Both swore they were Hutu, but the villagers dragged them off the bus. They seemed to accept their fate, and they died with dignity. I later learned they had been hiding for almost a week.

The FAR soldier who remained on the bus now turned on me. He pushed the muzzle of his gun into my ear, smashed his elbow into my chest and yelled, 'You saw me coming, why did you speed up?" I said I had not seen him running behind, which was true. He thundered at me, "Did you think you could drive faster than a bullet, idiot? *Ubu nagushwanyaguza*[23]." The young students, male and female alike, started to cry while Rwandan and Congolese professors and staff screamed and shouted: "No, no, none of us saw you were trying to stop us!" The FAR soldier kept at me: "Do you know these are the *inyenzi*[24] who killed Kinani?"[25] I told him that I did not think so as they had been here on campus with us, and that it must have been traitors in Kigali city who killed the President. Finally, the soldier smashed his rifle butt into my ribs and screamed: "Go, you fool. Don't let me see you here again, traitor!" I assumed from this interchange that this soldier had been targeting me, and that villagers had reported to him that I had been evacuating Tutsi to save them from the mobs. I don't know why he didn't kill me. Many Hutu did die trying to save Tutsi wives, children, neighbours and friends.

I drove on, feeling strangely calm but driving erratically and not really in control of myself. I was likely in shock, but in my role as driver I felt compelled to just keep going. Whenever I

[23] *I could just blow you away.*

[24] *Cockroaches – an insulting word used by Hutu, initially to refer to the invading RPF army, and then interchangeably to refer to all Tutsi.*

[25] *Kinani was a popular nickname for President Habyarimana, meaning 'invincible.'*

arrived at a roadblock, people would ask me as usual if everyone was okay at Mudende. I was so dazed that sometimes I forgot to say anything, and sometimes gave strange answers. I felt disconnected but something kept me going. The passengers thanked me and encouraged me as we went along, but mostly they sat in deadly silence as what they had just witnessed kept coming back to them again and again.

Even after 25 years, Charlotte, who was then a second year student in Mudende's Accounting program, is still thankful for that last trip that saved her life. While waiting for evacuation, Charlotte had been hiding in a professor's residence ceiling. Forced out by the militia and peasants, she dashed onto our bus without shoes. Agnes, who was already on the bus, gave her own shoes to this traumatized young lady in order to confuse the villagers who were chasing a barefoot girl out of the residence. "Everyone on the bus has shoes!" we all said to those in pursuit. Therefore, they concluded that the barefoot girl they were seeking never got on. Charlotte was saved.

When we finally reached Gisenyi and got to the Governor's office, we found around 600 Mudende students waiting for us. Everyone in the bus was silent and crushed, unable to respond to questions about the situation at Mudende. Their faces told the story clearly enough.

Finally, everyone was off the bus, and I sat wondering what to do with it. I knew I would not be going back to Mudende. Perhaps I could leave it with the local Adventist church to return to the University when things quieted down. Gendarme Captain Chrysostome from the Gisenyi base settled the problem by climbing up on the bus and demanding the keys, telling me that it was being commandeered for the war. A corporal chauffeur came and drove it away. I said goodbye to my lovely "Ship of Hope."

My task was almost complete, but I had one more thing to do: persuade the Governor's office to make buses available so that students and staff members starving at Gisenyi could get back to their homes in Southern Rwanda. After a few days, they managed to find some buses and the southern students headed out for Kibuye, Gitarama, Gikongoro, and Cyangugu. For some Tutsi and a few Hutu moderates it was too dangerous to stay in Rwanda, and they had no choice but to sneak across the border into the Democratic Republic of Congo.

From April 11th to Mid-July, I stayed in Gisenyi which borders Goma in the Democratic Republic of the Congo. Things were bad, with the civil war raging between the RPF and FAR. The Rwandan army was losing battle after battle. I couldn't go back to Kigali, nor could I go to my native province of Ruhengeri. The last time I managed to see my father was during my younger brother's funeral in May. He had been a professor at the Science and Nursing School in Gisenyi. We were close to each other and did business together, and his death left me feeling very alone. I lost him because of this Rwandan civil war. One day he let people know he was sick and the next day a messenger came to tell me he was dead. I was devastated by his death, but grateful for a substantial number of Rwandan Francs he had deposited in our joint business account just the month before, money that would help to save another life.

I stayed on in Gisenyi town with relatives as the area was relatively quiet. Refugees from the entire country arrived daily. Wounded soldiers, militiamen and deserters were flooding into the city from Kigali. By this time, the hunting down of Tutsi was almost over in Gisenyi town; they had killed as many as they could. Now the attention turned to those who were considered Hutu moderates, and for Hutu like myself who had protected Tutsi from being killed.

Some Hutu students were not happy with what I had done, and they spread a rumour through Gisenyi that I was an RPF supporter, and a traitor. When I was out walking in the city, students would come up to me and tell me directly that they weren't happy with what I did. My explanation was very simple; it wasn't logical that innocent students, students just like you and me, could have been involved in the presidential plane crash, and in any case no one, Hutu or Tutsi, should be killed because of his or her ethnicity. After several conversations my fellow students seemed to be convinced, but they kept coming back to it because there was a prevailing anti-Tutsi mindset. I watched my back because I knew I could be killed at any time, and I went out no more than I absolutely had to.

When the violence had all started in early April, I had been on campus at Mudende, and I had left my Fiat Ritmo at National Television in Kigali. While I was staying in Gisenyi, fellow journalists told me that it was still sitting in the parking lot. At first, I hesitated to go there to pick it up, feeling that it was too dangerous, but eventually I decided I could make it there if I took a different route through the southern province of Gitarama. I managed to recover the car, got my passport from my apartment and made it back to Gisenyi. That passport was a lifesaver and it got me from Goma through Kenya and then to the Republic of Togo in West Africa.

I stayed on for a while in Gisenyi, using the Fiat to go to Ruhengeri town to buy gas and reselling it in Gisenyi where the gasoline price had skyrocketed. I was able to live on the proceeds of this little business. After the RPF had taken Kigali on July 4th, we naively kept hoping that the Hutu government would negotiate, but that was not to be. On July 16th a FAR officer who had been fighting in Kigali told us: "We have enough munitions to fight for 7 more months." We were reassured and went back and told our housemates the good news. Everyone

went to sleep peacefully, not knowing that the 'news' was just misinformation.

The next morning at around 5:45 am, soldiers and militia woke the town of Gisenyi with intense gunfire. Civilians, some naked and others half-dressed, were running in all directions. Everyone knew that when militiamen and deserted FAR arrived in a city they would force the residents out so they could have a free hand to loot the town. I shook myself awake and grabbed my camera, suitcase and documents. I ran to the car with Christine, my fiancée at that time, and as I started the engine amid chaotic gunfire, militiamen in another vehicle arrived and started firing in the air to scare everyone.

The militiamen grabbed my video camera and gas can from the trunk. I quickly told Christine to go with her sister in the other vehicle, a red Toyota pickup. I wanted her to get away and avoid being raped if something happened to me. I got out of the vehicle and ran back to the trunk with the militia firing all around, but my camera was already gone. They shouted at me to leave the area or be killed. I saw that my fiancée had reached her sister's red pickup. They tore off toward the Kabuhanga border crossing into the Congo.

Christine ended up in a Kibumba refugee camp in the Congo while I was roaming around Goma town complaining about my camera and my vehicle that had been looted by the militiamen. After crossing the border to the Congo along with 2,000,000 other Rwandan refugees, I found her at the camp and was able to bring her back to Goma to stay with me. This is when we and millions of other Rwandans started a new life of homelessness and statelessness.

Chapter 9

ROAD TO EXILE IN THE CONGO

B Y THE END OF July, almost 2 million Hutu and a small number of politically vulnerable Tutsi had fled the country for Goma in the Congo; another 500,000 had made their way to the Benaco camp in Tanzania. With an additional 200,000 crossing into Burundi and 150,000 to Uganda, the invading RPF found much of the Rwandan countryside virtually void of people.

Exile is not something most people plan for. Flight is forced by circumstances; unexpected things happen. Suddenly I found myself in the town of Goma along with a vast horde of Rwandan Hutu. We were starting a journey that would prove to be endless and chaotic, for those who were lucky enough to survive the first days.

In Goma, refugees were sleeping in the streets, in schools, in soccer fields, and, if they were lucky, in peoples' backyards. Soon they began dying of cholera, and hundreds of corpses littered the streets. Many Western aid agencies were on the ground in Goma but they were helpless in the face of the

epidemic. Rwandans were dropping like flies. Local Congolese residents generously tried to help, but there were just too many of us, and soon Congolese citizens were dying too. Our remains were polluting their city, and cholera wiped out guests and hosts alike.

I was getting desperate to leave Goma and decided to try for Nairobi in Kenya, but I didn't have enough money for airfare for both my fiancée and myself. I tried to borrow from friends and acquaintances but few had money to lend. Those who still had some means were uncertain of their future in Goma, not knowing how they were to live and survive. But after several weeks of squeezing small amounts from friends, and having sold the bulk of my clothes, I was able to scrape together $230 US dollars for an airline ticket and $50 for a boarding pass and visa.

In Goma I ran into a group of Tutsi students from Mudende. I was relieved and happy to see them alive, and they were genuinely thrilled to see me too; they thanked me profusely for saving their lives. Retty was there, along with Evy, Claudy, Marcel and others. They were headed back to Rwanda and invited me to go with them, but I declined the invitation, as they surely knew I must; we all were aware that the RPF were carrying on massacres in a second wave of genocide, but against Hutu this time. I would not be welcome back in Rwanda any time soon. But we still naively imagined that, somewhere down the road, there would be another chance to rebuild Rwanda into the good place we had known – the lost paradise we imagined it to be.

At our separation we were tearful, but we promised to see each other again one day if God willed it. From that moment I felt the full weight of the division between Hutu and Tutsi in Rwanda. We had crossed ethnic lines as childhood friends, classmates, teammates, co-workers, business partners, couples,

and relatives. But politics always resurfaced to break those bonds. In my view, Tutsi and Hutu are not born evil—it is Rwanda's endlessly corrupt politics that is the fertile breeding ground for criminal minds. So now I would set out to find refuge in Kenya, but before leaving, I would receive some very bad news, which would cast a pall over my life from that moment to the present day.

As the RPF took power in Rwanda, several Hutu fled the country and became refugees in neighbouring countries, or elsewhere around the world. I thought, though, that I might have the option of returning to Rwanda. I had saved Tutsi lives at Mudende University and had spoken out against the Tutsi mass killings, and my record might protect me. Moreover, I had heard on the radio that Hutu people I knew had been given prominent positions under the new RPF government. How, after all, could the inexperienced new Tutsi government run the country without the expertise of the Hutu government civil servants that had fled the country with millions of other Hutu in the new Diaspora?

I could not stay in Goma, where I might be targeted by militia for interfering with their killing spree at Mudende. Revenge and assassinations were common in the now-chaotic Goma, and especially in the refugee camps. There was also deep anger against the Tutsi forces that had kicked the Hutu out of Rwanda. Given what I now know about the RPF's *modus operandi* at that time, I likely would have been killed upon my return; the RPF rebels were killing Hutu without making any distinctions. But I was naïve and overly optimistic; I couldn't imagine how the RPF government could lead the country without the skills of the Hutu population and the 40,000 Hutu soldiers waiting in Congo. My thinking was that the rebels knew how to fight a guerilla war but not how to run a country.

I was right about that, but that line of reasoning would not have kept my head attached to my neck had I returned.

The bad news that I received put an end to my wishful thinking. At the Hotel Karibu in Goma, I ran into my uncle's wife, Annas. She told me that she had read in the Rwandan newspaper Rushyashya that my name was on a list of 400 Rwandan Hutu 'génocidaires[26]' released by the RPF. All were accused of planning and perpetrating the 1994 Tutsi genocide. I was deeply shocked; I didn't believe there even was such a news story until I heard it from other people I knew. I ran and checked the newspapers in several hotels in Goma, without success; I couldn't lay my hands on the story in print. However, enough of my friends confirmed having seen the so-called génocidaires' list with my name on it that I had to accept that it was true.

But what devil had put my name on this list of the imaginary 400 Rwandan genocide masterminds? I say 'imaginary' because the International Criminal Court for Rwanda, ICTR, has never found any evidence whatsoever of a plan for the 1994 Tutsi genocide. When Hutu Power Prime Minister Jean Kambanda pleaded guilty to genocide on May 01, 1998 during his initial appearance, no such crime had ever been demonstrated by the court. In my opinion, we must reject the court proceedings and find fault with Kambanda's legal representation. Note, as well, that of all the 56 Hutu prosecuted by the ad hoc tribunal, none was actually charged with genocide.

I made every effort to find out where the list had come from, and how my name had gotten on it, but with no success. Later, in Nairobi, I heard from a reliable source that a Hutu

[26]　The term 'genocidaires' was used after the 1994 Tutsi genocide to refer only to Hutu who were involved in the genocide. Today, the term is commonly used to refer to Hutu and Tutsi who were implicated in the 1994 Tutsi genocide in Rwanda and the 1996 Hutu genocide in Congo.

from the moderate RFP-leaning MDR party, Jean Higi, who had taken refuge in Nairobi from April 8th through July 1994, was the one who had added several names, including my own. Shortly before President Habyarimana's death, Higi had been promoted to a top civil service position as the National Public Media's CEO, after 10 frustrating years of maneuvering his way there. He was enraged at losing his new title. Angry, hungry, and hopeless in Nairobi, he forwarded the names of people he knew to those busily composing the list of *génocidaires,* and created imaginative allegations against each one, hoping to curry favour and get a position with the new government. Higi had found a list of RTLM shareholders in his predecessor's office, and he simply transferred these names to the génocidaires' list as well. His reckless scheme actually worked, and he was rewarded with the offer of a position as Minister in RPF's government, but in the end he chose to immigrate to the USA and refused the position. The collateral damage, and the destruction of the lives of those on the list and their families, did neither him nor anyone else any good at all. When he candidly told all this to the people who were hosting him in Nairobi, they threw him out of their house, appalled at the depths of his dishonesty, cynicism, and lack of ethics.

Now, in Goma, the publication of the list had lit a fire under me, and I focused all my energies on getting out. I had a ticket, a visa, and a paltry $50 US for pocket money. Christine and I had decided that I would go first and she would stay until I could raise enough from European friends to bring her to join me in Nairobi. My cousin and elementary school friend Emmaus had been working there as an accountant and auditor for years. In June, I had already helped a Rwandan couple, a Tutsi woman and Hutu man whom I knew from elementary school, to escape to Kenya through Goma; I had put them in touch with Emmaus, who I knew would put them up when

they first arrived. From them, Emmaus would know my arrival was likely to be soon.

I arrived at Goma Interregional Airport full of plans, which quickly proceeded to fall apart. As soon as I arrived at the airport, I found out that the Congolese soldiers had a tradition of exacting 20 US dollars from every departing passenger. I flatly refused to pay and told them I didn't have anything to spare, just my suitcase and my documents and that was it. I suppose I looked prosperous to them in my old brown Belgian leather jacket, and I could see they didn't believe me. The Congolese corporal ordered me to sit in the waiting room with the other passengers but warned me that I was making a serious mistake by not paying up. I understood very well that bribery was part of the culture under Mubutu's regime, but I only had my very hard-won $50, and I knew the entry visa at the airport in Nairobi would cost $30. That left me only $20, and I had no idea what things would be like in Nairobi. I had never been there, and I was not enthusiastic about the idea of arriving there with no money, especially as this was Friday, the 13th, which Rwandans view as an unlucky day.

When I was in the waiting room, I could hear the public address system calling Rwandan names to go to the customs office one after the other. I knew they were going to be hit up for bribes, regardless of their economic status; the customs and military would take the clothes off their backs if they had no money. Rwandan refugees in the DRC were especially vulnerable and easy prey. Not long before the time of takeoff, the same corporal who had harassed me earlier came back and took me out of the waiting room into another open area. He, another soldier, and a lieutenant started to punch and kick me. I didn't hit back but I avoided their soccer kicks and blocked their punches as much as I could. If I had been in a position to fight back, I would have taught them a good lesson. I found it hard

to believe they were really soldiers. They seemed physically weak and malnourished, which was a good thing for me, given the circumstances.

Finally they managed to grab my wallet from my back pocket. I assumed I would now say goodbye to my $50, but to my amazement they took only the $20 they had asked for, leaving the other $30 and letting me go. I felt incredibly lucky as I climbed on board. Had I missed that flight, it would have been hard if not impossible to get another one later on, as Kenya Airlines had just changed their policy and would henceforth only sell return tickets − which I assume was the airline's enterprising way of making a nice profit from all the departing Rwandan refugees, since they would never have to provide them with a return flight.

From that day to this, I have hated the Swahili language, which the soldiers were speaking as they were beating me, yelling "Pesa, pesa!" meaning 'money, money,' over and over again. As I continued on to Nairobi, I vowed never to speak Swahili, which I now identified as the language of Congolese bandit soldiers, and for the five months I stayed there, I would neither study nor speak it, though it is the main language in Kenya. Instead, I would take English courses at Kenkom House and Graffins College in Nairobi.

All the passengers on the plane had seen the soldiers beating me. They were happy that I could board, and they gave me moral support, which comforted me a good deal. Two hours later, I was finally in Nairobi. At the airport, passengers needed to buy a visa upon arrival. I dutifully handed over my last $30 for an entry visa, but in Kenya it seemed it was also normal for customs officers to require a bribe. They didn't beat you in Kenya, preferring a soft diplomatic sort of British colonial corruption. If you didn't pay the bribe, they refused you entry and sent you back where you came from. I doubt that any of

this has changed in the more than 20 years since I was there; I found institutionalized corruption everywhere I went in Kenya.

Now a customs officer, a lady, walked down the waiting line at the customs counter and collected bribe money from all the passengers; I presumed she would share the takings with all the employees at the end of their shift. Rwandans were targets here as they had been in Congo; we had a reputation of being wealthy. So now, though I had my visa in hand, I was in danger of being sent back to Goma.

In the waiting line I explained my situation to a Rwandan who had come in on the same flight. He not only agreed to give me enough for the bribe at the airport, but also offered to pay for my hotel until my friend Emmaus could come and cover my costs. In fact, he told me that if I couldn't find Emmaus, that would be okay too; he could afford it. He was carrying a thick wad of bills, thousands of dollars, and had come to Kenya to buy spare parts for his Mercedes. But in the end I didn't have to take him up on his offer, as the next day when we went to Emmaus's office we found him in.

Emmaus was shocked to see my eye, swollen from the beating, but I assured him I was okay. I borrowed $20 from him to pay back my new friend, but this gentleman refused the money. He said he was helping me the same way I would help others on my road to exile. Later on, Emmaus and I helped him buy replacement parts for his vehicle and he happily headed back to Goma. Later on, I would hear that Congolese soldiers had stripped him of all his assets, including his Mercedes, and he had become just one more destitute refugee in a squalid camp in the Congo.

As for me, I was confused, desperate and 2000 kilometers from home. I couldn't accept that I was now a refugee. I knew I couldn't go back to Rwanda but I still had an irrational hope that I might return home. There were many Rwandan refugees

in Kenya, so I was not alone. Many were as broke as I was, but there were also plenty of Rwandan businessmen, government ministers, chief officers of public corporations, private and public bank managers and military officers. Some of them were loaded with money, especially those who had very effectively looted the country during the months when the interim Hutu government was on the run and out of control.

Because I didn't have money, my friend Emmaus supported me with shelter, food, pocket money and tuition for my English classes. I was highly motivated to learn English. I enjoyed the food and the music on the streets in Nairobi, and I loved listening to people preaching from the Bible on the streets and on the buses. I liked their enthusiasm and it gave me an opportunity to listen to spoken English.

Nairobi is a beautiful modern city that looks much like North American cities, and the cost of living there was high. Christine soon joined me, and we would have been in trouble had Emmaus not generously taken care of both of us. He was the first of many good friends worldwide who made a real difference in my new life. But we couldn't stay any longer. I didn't think I could make a living in Kenya, and my name on the list of *génocidaires* meant certain death should I return to Rwanda, and probably even if I stayed in Kenya. I decided to relocate to Togo in West Africa and continue my university studies there. I would bring Christine there when I could put together enough of an income to support her. Prior to going to Togo, I had secured a Rwandan passport at the Rwandan embassy in Nairobi and had bought a return ticket, which I had sent to Christine through my best friend Alfred. By the time I arrived in Togo, I learned that Christine had arrived in Nairobi and was staying at Emmaus's house. She enjoyed staying with Emmaus's wonderful Kenyan wife, Esther, until my return for our traditional, family marriage in July 1995.

So, in January 1995, after five months in Kenya, I arrived at the University of Lomé in Togo, my third country since my escape from Rwanda. There I would undertake a Bachelor's degree in Philosophy, and a Master's degree in the Sociology of Communication. I had given up on my studies in Education at Mudende University and I found a new passion for Philosophy and Sociology.

I fell in love with Togo. The culture and people made a wonderful contrast with both Rwanda and Kenya. In Kenya, I had found people overly love money- and business-oriented, and rather indifferent to people. In Rwanda, people are prone to suspicion, and conflict and violence are endemic. I was used to that of course, and so Togolese hospitality and the gentleness of the society just blew me away.

Togolese treat other Africans with dignity, respect and affection and help them without hesitation. I made friends effortlessly, even on the first night I arrived in Lomé, the capital. I could eat in five different homes in a day, and bring one or two Rwandan friends with me each time (I should note that, outside Rwanda, you will never see a Rwandan alone; it's almost unthinkable in our culture). My new Togolese friends wanted to have me over to their homes; students, classmates, and professors would always invite us Rwandans, knowing what kind of horrors we had left behind us.

One day, I attended a Catholic mass on the campus led by one of these new friends, a university priest, Father Atayi. He was a confident man, with a mastery of French befitting one of the best-educated individuals in the country. We tremendously enjoyed long and far-ranging conversations in French, and he offered to pay me if I would call him to chat in French on the phone. This was really a ruse, a way to let him financially help me without being too obvious about it. Father Atayi was a man

who enjoyed conversation, but he genuinely cared about me and my small family's well-being.

One day, during the Sunday mass at the Lomé University campus, Christine, who was pregnant, fainted in the 40-degree heat. Immediately a friend, Dr. Norber Boko, and another man I didn't know hurried to help her. I was not too alarmed as this was the third time she had fainted in this way, but they rushed her to the hospital on campus, taking her Rwandan friend Claudy along, while I stayed behind to pray and finish the mass. Father Agboli, who was leading the mass, asked us to pray for Christine's recovery, and I was grateful for their support.

After the mass, I hurried to the hospital and found that Christine was doing much better. I met the second man who had helped to take her there, a modestly dressed man in West African traditional clothes. I presented myself to him, and he introduced himself as Mr. Liwoibe Sambiani, Minister of Work and Social Affairs in the government of Togo. I said "Great!" but I wasn't really impressed and didn't take his statement at face value. I knew that in Togo there are as many former ministers as there are donut sellers on the streets. He said that he was a member of the sitting government, but I simply did not care. He told me that he needed to go home but he would be back again to make sure we were okay and give us a ride to our apartment. I could see he was a generous man, but I was beginning to take that for granted in Togo. When Christine, my wife, felt well enough, we decided to go take a taxi at the Hospital's gate. Minister Sambiani showed up as he had promised, well-dressed in a navy-blue suit and driven by a military driver or chauffeur. The soldier took his assault weapon out of the back seat so that Christine and I could sit. I panicked a bit; I was getting flashbacks to the rogue soldier who had threatened me on the bus at Mudende. Could it be they were taking me to jail as I had not paid enough respect to the Minister? I now realized

he must actually be a minister in the sitting government. Why would he want to give me a ride?

This was a mental state I found myself in from time to time, in which I did not trust anyone. I had zero tolerance for people that I did not know. I saw everyone as a potential Rwandan spy, out to harm me in one way or another. But Minister Sambiani drove us home, and he promised he would come and visit me sometime. At that moment, I didn't care whether he ever came back, and I assumed that would be our last contact. I thanked him for the ride and wished him a good day. Before he drove off, he shocked me by giving me 30,000 Francs CFA, which was a month's pay for a Togolese school teacher.

That would not be our last meeting, and from that day on he frequently invited me to his office where we talked about life, though not about politics at first as I was still not ready to trust him. Talking about Rwandan politics was taboo to me as I knew the story of Tutsi victims and Hutu perpetrators was becoming the accepted narrative everywhere. As a Hutu, I had to expect that I would be seen as a bad guy. If I told my story straight up- -that General Paul Kagame had killed President Habyarimana and thus intentionally provoked a Hutu massacre of Tutsi, and that I myself had done everything I could to save the Tutsi-- who on earth would believe that? I wanted to stay away from that conversation at any cost. It was just too risky. However, Minister Sambiani continued to keep me in his thoughts.

Later on, there was an international security summit in Lomé to promote peace in Congo, DRC, between the government of Mubutu and the Congolese rebels backed by Rwanda, Uganda, and Burundi. Minister Sambiani invited me to go with him so he could introduce me to the Rwandan delegation led by former Rwandan Ambassador Callixe Habamenshi, whom I had met at his home in Kigali several times and whom I considered my friend and mentor.

In Togo, it's common for visiting governmental officials to meet with local students and provide them with social and financial support. I think this is what Minister Sambiani hoped would happen for me, that I would be helped out and my interests advanced by the Rwandan delegation. However, any contact by me with Ambassador Habamenshi would have put him in a difficult position. I told Minister Sambiani that I knew his intentions were good, but I could not accept his offer for political reasons. The Hutu-Tutsi conflict had torn apart the fabric of Rwandans' cultural and social relationships. Even Rwandan families who had members inside and outside the country could not communicate freely with each other because of their different political loyalties, especially in those years of 1994-1997 just after the Tutsi genocide. Minister Sambiani was a bit confused by my response but accepted my polite refusal of his offer.

I stayed in Togo for 4 years. Although it is among the five poorest countries in Africa, people there are friendly, outgoing, and hospitable to foreigners. It's a peaceable place; in all the time I was there, never once did I see men physically fight. There were plenty of arguments, of course, but they always remained in the realm of words. In the Central and Eastern African countries of Rwanda, Burundi, Eastern Congo, Uganda, and Kenya, I found that men had a short fuse and frequently resorted to physical violence to resolve conflicts. Women in Central and Eastern Africa don't engage in physical fighting, but in Togo and the rest of Western Africa I saw women brawling on a regular basis, which seemed odd to me. Perhaps it's related to the fact that in Central and Eastern Africa, women have a high level of social respect and aren't expected to do a lot of household work, whereas in Western Africa, women receive less respect and are more confined to the home. Polygamy is a longstanding tradition in Togo, even among government

officials like the late President Eyadema, who had many wives and concubines, whereas polygamy among intellectuals and civil servants had been prohibited in Rwanda by the early 1964 marriage laws.

Togo remains vivid in my memory. It gave me what I needed and brought me the good luck I wished for. The quality of university instruction was generally good; professors all held PhDs. At the same time, study materials and classrooms were of poor quality. In the Economics department, a classroom with a capacity of 400 students would generally be filled to overflowing with 600 students or more. Many students had to listen to the lectures from outside the room, and to accommodate this, the professors lectured through bull-horns or megaphones. If you wanted to get a seat inside for an 8 am class, you'd have to be there at 5am. Pass rates were pathetically low – after the first year of study, 60 percent of students would be gone.

We had just finished our class at the University
of Lome- I am the fifth on the left.

In African universities, the academic environment is selective and harsh, and this is made worse by the number of students who don't attend regularly or who lack personal and family resources to support their studies. Even among the graduates who manage to make it through, a high percentage still can't find the jobs they've prepared for, and end up becoming motorcycle taxi drivers or the like, which is still considered to be a pretty good outcome.

Early in my time in Togo, I was still in deep denial and did not consider myself a refugee. I had my passport and a multiple entry visa. But the more I learned about what was happening to Rwandan refugees elsewhere, the more I became convinced that I should seek refugee status. I went to the offices of the United Nations High Commission for Refugees, UNHCR, in Lomé, where I met Madame Ajavon, a very tough, power-abusing woman who could grant or refuse refugee status. As the UNCHR representative in Lomé, she had an inordinate amount of power that could make others' lives miserable. She had no more than a high school education, and her understanding of international issues was close to nil; she had come into the UNHCR more or less by chance a decade before, and still seemed to have no idea what she was doing. International protection was beyond her capacity. Based on the sole fact that I'd been in Togo for more than a year, she denied my application, though there were numerous other 1951 Geneva Convention factors she should have considered.

A week after Ms. Ajavon rejected my application; my friend Valence and I were walking along the beach, looking out on the vast Atlantic, when we decided on a whim to drop by the UNHCR office. We started chatting with the security guard, who told us Madame Ajavon was on a work trip outside the country, but that Mr. Malou from UNCHR Regional Headquarters in Sénégal was filling in for her while she was

away. We excitedly asked to talk to him; we wanted to see if he might treat our applications differently. As it turned out, Mr. Malou was an educated man who knew how to interpret the 1951 Geneva Convention Relating to the Status of Refugees, in contrast to the limited knowledge of Madame Ajavon. Immediately after listening to our grounds for application, he assured us we would have our refugee status letters from Senegal within 3 weeks. What a blessed relief! From that day on I would be protected under the Convention, on the grounds that I would face persecution if I returned to Rwanda.

By the time Madame Ajavon returned, there were so many Rwandan refugees who had come through the Democratic Republic of Congo, Zambia, Kenya and elsewhere that she couldn't remember when or if she had given me refugee status. I assumed she thought that she had given it to me, because she suddenly began treating me very nicely. But black clouds appeared on my horizon when she started to hear contradictory allegations against me from Rwandan refugees. Hutu Rwandans told her I was a traitor who had sided with the Tutsi RPF against my own people. Tutsi told her that I was with the murderous Hutu Interahamwe militia, and had killed Tutsi in Rwanda. The treacherous politics of Rwanda had followed me into exile.

Madame Ajavon had only the most rudimentary knowledge of the political and ethnic complexities of Rwanda, Burundi, and Congo. She couldn't understand the difference between Hutu and Tutsi. Before the wave of Hutu refugees in 1995, the only Rwandans passing through Lomé had been a dozen Tutsi. These former Tutsi refugees had taught her that light-skinned people were Tutsi and dark-skinned people were Hutu. In Togo, and in coastal West Africa, light skin is highly regarded, because it is associated with having some measure of European blood, and as such confers high status. Togolese with Brazilian and German ancestry and who retain foreign names are believed

to be superior to others, and do very well in politics and in government.

It so happened that I was light-skinned, which met with Madame Ajavon's approval. She applied the formula she'd learned literally and in her mind I was Tutsi, superior and bright. My high level of education fit this preconception perfectly, as did the careful respect with which I treated her; my stars were now aligning very well.

Because a very large number of refugees had now ended up in Togo, UNCR headquarters in Geneva made UNHCR Lomé an independent sub-regional bureau for Togo, Benin, and Niger. Under this new system, Stéphane Jaquemet, a Swiss national based in Geneva, became the Director of UNHCR Togo. Intelligent, empathetic, and fair, he made changes in policy that improved the lives of refugees in Togo significantly. He gave refugee status to many applicants who had been declined by Madame Ajavon, and denied only political people facing an international embargo because of links to the so-called *génocidaire* regime. What is more, he provided vehicles and money to Togolese agencies that were aiding refugees. Because I had lived in Europe and was accustomed to that life and culture, it was far easier for me to develop a good rapport with Stéphane than it had been with Madame Ajavon.

Even so, I knew that nothing was guaranteed, and that the *génocidaire* list might well come back to haunt me. Sure enough, one day Stéphane ordered me to meet him at his office. When I got there at the appointed time, I found more than a dozen others ahead of me. I would wait, anxiously, for over five hours. When I finally was called into his office he informed me that my refugee status had been suspended because he had been informed that I was among the 400 Hutu Rwandan génocidaires who had planned and executed the 1994 Rwandan

Tutsi genocide. I immediately denied the allegations and stated my intention to appeal the suspension.

My appeal had to go to Geneva. In the meantime, I had no financial assistance as I had lost my refugee status. I started visiting Stéphane once a week to ask him if he could give me some money from his own pocket, which, to his great credit, he did. I imagine the constant pressure I kept up, which may have motivated him to expedite my appeal process; I was also using the visits to systematically explain to him what had happened in 1994 and more recently in 1996 in the Congo.

After four months, the Geneva UNHCR Headquarters upheld my appeal, finding that the allegations had no grounds. I regained my refugee status through the front door. This process had been painful but it made me much more popular with other Rwandan refugees in Lomé, with the exception of exiled Interior Minister Faustin and three of President Habyarimana's former Directors who had been denied refugee status, and whose appeals had been rejected.

The Rwandan refugees were still, of course, divided not only by ethnicity but by region and former political affiliation. The University was one place where these differences could be mitigated and people could act with a common purpose. In 1995, there were about 50 refugees from Rwanda and Burundi enrolled at the University of Lomé. Many did not have scholarships; some were in precarious financial situations. I collaborated with other students to establish a student association, the Burundian and Rwandan Refugee Student Association of Togo, whose objective was to find scholarships for its members.

I corresponded with local and international scholarship programs in Switzerland, Belgium, Canada, France, and the US, and finally succeeded in getting an organization called

Foncaba, in Belgium, to provide 10 scholarships for students in the Association. I myself received a scholarship to allow me to finish my Master's degree. Other beneficiaries went on to settle in Canada, France, Germany, Netherlands, Poland, Togo and the UK, and I have kept in touch with them over the years.

I was able to put my life together in Lomé, and for that I have many Belgian friends to thank: Lieve Boon Simoens, the Ward family, Nelly Pullinx, Brother François Butteners and others. All helped me financially during my four years in Togo. My first daughter, Clary, was born there in 1997 while I was still busy with my Masters, and that made me even more thankful for their caring and assistance.

I had now applied for immigration to Canada on the advice of friends, especially, Stephane from UNHCR and his wife, who strongly suggested we try to settle in a western country. They believed that we would have a better life there; it wasn't what my heart wanted, but logic told me that my family's safety in Africa would be precarious. I sent my application to the Canadian High Commission in Accra, Ghana, and after four months, I received a letter saying that my application had been approved. I was very fortunate to get it so quickly. I met with a Canadian immigration officer, John Zawisza, at the Hotel Le Bénin in Lomé in Togo. Mr. Zawisza, who was nearing the age of retirement, had been born in Great Britain, and had himself immigrated to Canada and become a citizen; he had also worked and lived in Nairobi. He had a wide range of international experience and readily understood what I'd been going through. After my interview, he told me that I had scored enough points to qualify for immigration, and should expect to land in Canada within 15 months.

John and I really connected during that interview and I was able to freely ask him questions. He had a question too, about the origin of Tutsi-Hutu violence in Rwanda and Burundi.

I took an hour explaining and drawing maps, listing dates and providing details about the genesis of the bloodbath. I explained the history from the 7th century through the 1960's independence era and right up to the 1996 Rwandan Hutu genocide in the Congo. He told me that I had made his day, and that having this background would be invaluable in his settlement interviews with Rwandans and Burundians.

Hearing I had been accepted to immigrate to Canada was good news, but I was torn about leaving Togo. I was now well-positioned to start doctoral studies in Lomé, and I had good relationships with my professors. Research projects were coming my way, and I was learning how to undertake contracts with international organizations like the United Nations Development Programme (UNDP) and UNHCR. I doubted it would be possible to complete a PhD in Canada. But I had to be realistic. I knew that my family's security would be guaranteed in Canada whereas I would be increasingly at risk in Lomé; Kagame's government had started to track down high status Rwandans who had fled the country and refused to return. I knew that my name on the *génocidaires* list guaranteed I would be among those targeted. Togo was not far enough away from Rwanda, and it would be easy for Kagame's killing squads to operate there.

Our Canadian visas arrived in April of 1998, but I stayed in Togo until June so I could complete my Master's degree. Two days before our departure, I went to UNCHR to say goodbye to some friends there. The new Director, George Ngango, from Cameroon, asked to talk to me about the allegations that I had committed war crimes and crimes of genocide in Rwanda. I was furious at having to go over all of this again, and I insisted he call Stephane Jaquemet in Geneva to verify I had been cleared. He called Stephane on the spot, and Stephane told him to stop harassing me, that my case had been investigated and resolved

already. I now told George that I was leaving for Canada in 2 days; and asked him to provide me with transportation to the airport and an escort to get me there safely. He argued initially but finally saw he had been mistaken, and decided to give me what I'd asked for. On our departure day, George came out to the airport to make sure all three of us were safe. On June 15th, 1998, we left Lomé.

From Lomé to Paris took eight hours, from Paris to Toronto another eight. After being processed through Immigration in Toronto, we continued on to Vancouver. I was quite confused about where I was going. I had asked John Zawisza, the immigration officer in Lomé, to send me someplace where the weather was similar to that of Rwanda or Bordeaux. I didn't realize these climates were not on the Canadian menu. John had suggested Vancouver, and I had gotten it confused somehow with Trois-Rivières. In fact, I didn't really mind where in Canada we settled, as long as it was near Ottawa and not far from Montréal. I did not know that Vancouver was three time zones away from those cities, in this country that was as vast as a continent. At this point, I was too exhausted to focus on geography. My arrival in Canada seemed an unimportant event. I had lost my future in Rwanda and couldn't bring myself to grapple with anything else.

The 4-hour flight from Toronto to Vancouver seemed endless. The flight attendant did manage to straighten me out about the difference between Vancouver and Trois-Rivières. I had had my landing papers, naming Vancouver as my destination, for two months, and hadn't even bothered to find out about the place where I would live. I laugh now when I think about it. But I was not psychologically ready to leave Rwanda, much less leave Africa for another continent. The grief and loss associated with losing one's homeland is very real: it

would take me 14 years to truly leave Rwanda behind and start to focus on building my life in Canada.

By the time we arrived at Vancouver International Airport, I had lost all sense of time. A Chinese-Canadian immigration officer was waiting for us at the airport with a sign with my name, and a picture of me and my wife and our 11 month old daughter. He quickly found us, but I couldn't speak much English and barely understood anything he said. He found us a taxi and we headed to the motel in downtown Vancouver where we were to stay. During the drive, I asked him where he was from, and he said he was from Canada. I was astonished. I challenged him, saying he must be from China, he was obviously Chinese. He didn't take offense – I think he could see that I was completely clueless about life in Canada. In Africa, we were used to being able to identify a person as Asian or European or African by their skin colour and appearance. It took a while to understand that this African approach just didn't work in Canada. In fact, I learned you could offend people by making those kinds of assumptions, or by asking them bluntly where they were from, as opposed to more indirect questions like, "You have a very interesting accent – where is it from?"

I was so tired that I slept most of the next three days. I'd never experienced this kind of jet lag travelling from Africa to Europe. I felt drained and disoriented. I knew no one in Vancouver, and my English was so rusty and rudimentary that I had to communicate with body language and hand gestures. But I was curious about the city, and rode different bus lines and Skytrain lines to their terminus and back to get a feel for the geography of this strange place.

During that first week, I met a fellow Rwandan, Kiragi, who was living in nearby Surrey, a sub urban city, and suggested I might settle there, but I wanted to be in the centre of everything. I still knew not a soul in the city, but one day

when I was walking my daughter in her stroller, I met a lady named Jill who just fell in love with my baby and invited me and my family over to her house.

I didn't think she was serious, and if she was, I assumed her husband would not be pleased at her inviting us. I had never received a random invitation of this kind in France or Belgium, and I thought Canadians would be much the same. I was operating on the old cliché that, if you show up when a Western family is at the dinner table, they won't invite you to join them, but will give you a newspaper to read. Everywhere in Africa, if you go to someone's house when people are eating, you can jump in and eat with them whether they know you or not − that's the norm.

A couple of days later, I called Jill, just to be polite. I got the answering machine and I concluded that I'd probably been right, and that the invitation wasn't supposed to be taken literally. But amazingly, they called us a couple of days later and confirmed the invitation. Jill and her husband James have been friends from that time until this, and the first of many in Canada. Through coaching community soccer and operating a soccer school, I've become familiar and well acquainted with much of my Vancouver West Side community. It's been a long process of cultural learning.

In the first years, I hung onto to my academic ambitions and expected to reestablish the same career path I began in Rwanda. By 2000, I had completed my Grade 12 English at Vancouver Community College while coaching soccer and teaching French to feed our family and pay the rent. Working hard was my nature and something I had learned from my parents at a very young age. I became fascinated by the idea of launching an international business in Africa exporting second-hand clothes to Zambia, so that I could undertake PhD studies at the University of British Columbia. My friend Jill encouraged my

business idea because it involved recycling, which she approved of, and looked like it stood a chance of making a decent profit.

I got the business off the ground pretty fast, and soon succeeded in shipping a container of clothes to Lusaka in Zambia. Then it all went up in smoke: my Rwandan agent in Zambia, Jean Claude Bikino, sold the whole shipment and the 20-foot container as well, and ran off to Mozambique with the $20,000 US profits. That quickly ended my export schemes. Now I understood that doing business in Africa at a distance was high risk, and in fact I met Senegalese and Congolese Canadians who'd had similar disasters. The used clothing business could be a gold mine, but you couldn't make it work unless you could go to Africa and take care of things on the ground. I couldn't do that on my Rwandan passport. Too eager to make a go of it, I had ignored some good advice. It was an expensive lesson, but I learned from it. Now I decided to focus on a local business that I could control, and I set up a soccer academy that is still very successful today.

I had lived through both good and bad experiences in Africa. Some had left scars, while others were tough but had positive outcomes. When I was in Lomé in Togo, I faced war crime allegations that hindered my application for refugee status, but I didn't take that very seriously. After all, African governments and African officials are well known fabricators of such allegations, and there's a culture of misinformation and corruption. I didn't think Rwandan war criminal allegations would be able to follow me when I left Africa behind. I was shocked when my Rwandan past began to derail my life in Canada.

I had come to Canada as a landed immigrant. According to the Canadian Immigration Provisions, I would be eligible for Canadian citizenship on June 16, 2001. Once three years had passed, I duly applied for my citizenship. Shortly after, I received

a letter confirming that my application had been received and was being processed. After one year of corresponding with Citizenship and Immigration, I suspected that something was delaying my application. Responses to my queries seemed superficial and evasive. Year after year, I pressed my application for citizenship, but to no avail. Despite a long series of requests, letters, and phone calls, no one ever told me the reason behind the delay. Gradually it dawned on me that the Rwandan genocide allegations might be coming back to haunt me.

I gradually sank into something akin to paranoia. It started with a growing reluctance to talk about Rwanda and anything related to the genocide. I became increasingly suspicious of everyone I came in contact with. I trusted neither my soccer school clients nor even my Canadian friends. I began to feel I wanted nothing to do with friends or friendship. I became convinced that my home phone was being tapped. From time to time, I could hear people talking in the background when I was on the phone. Sometimes they were speaking the Kinyarwanda language. It happened often enough that I became convinced someone was monitoring my conversations.

I was living a double life. I was doing well in school, had a social life, and was making a reasonably good living, but my lack of progress towards obtaining my citizenship, and the total vacuum of information about the progress of my application, left my head spinning with an endless internal dialogue.

Anything out of the ordinary could put me into a tailspin. When three formally-dressed strangers, two women and a man, came knocking at the door of our rental house one day, I immediately thought they were CSIS[27] agents. I asked

[27] CSIS: Canadian Security Intelligence Service investigates threats, analyzes information and produces intelligence. It then reports to, and advises, the Government of Canada to protect the country and its citizens.

them who they were, and they said that they were Jehovah's Witnesses. I didn't believe their story, though I didn't let my suspicion show. I thought it was a ruse to get into my house and check up on me. When I asked them what they all did, the man, Bruce, said he was a salesperson, one of the women said she was a recovering drug addict, and the other woman, Veronica, told me she was an RCMP officer. From this, I deduced that they had come to bug my house. I felt deeply afraid. I invited them to come back for another visit, and to leave pamphlets or other literature at the door if I wasn't home. I thought this overture would show them I had nothing to hide. They did return, on many occasions, as anyone familiar with Jehovah's Witnesses' proselytizing approach will understand, and we always had a lively conversation about their beliefs. They came to assume I would one day join their congregation, and I went along with that. After months of their continual visits, I decided to move away without telling them so that they wouldn't be able to spy on me any longer.

I moved from West 49th Avenue to West 69th Avenue, and hoped I had lost them for good. However, by sheer misfortune I had managed to relocate two blocks away from their Kingdom Hall, as they call their church. Days later, who should appear on my front porch but Veronica, the RCMP officer. I was thunderstruck! She was with another Jehovah's Witness, a man who introduced himself as Christian, a former missionary in Russia. I thought to myself that there was no way you could undertake a Jehovah's Witness mission in Russia unless you were a CIA agent. On top of that, Christian aroused more suspicion by asking me if I'd be willing to teach him French, as he'd heard I had a good reputation as a French teacher. I decided to do it, and to charge him a high price per hour, and we set up a couple of sessions. During our lessons, he told me that he had lost his government job, and was applying for another. I began

to doubt he was a CSIS agent, as he gradually filled in pieces of his own life story during our French classes.

I was feeling very conflicted and felt I had to find out whether these people were really investigating me or not. I decided to start attending Jehovah's Witness meetings on Sundays, so that I could observe them and figure them out. I found that most of the congregation were families with children, from a wide range of social, economic, cultural, and ethnic groups. I also found out that the sect was obsessively focused on bringing in new members. Bruce, one of my original three visitors, who lived not far from my new house, was an elder in the congregation and very willing to answer my questions. I did my research gradually over several months and even attended their yearly convention in Chilliwack, a hundred kilometres outside Vancouver. I made particularly sure to ask everyone I met about Bruce, Veronica and the other woman who I now knew as Joanne – my 'spy friends,' as I thought of them at the time.

My experience with the Jehovah's Witnesses was initially traumatizing, but I'm now happy I was able to meet them and learn about their beliefs. As my suspicions started to recede, I became friends with Bruce and his wife Joanne, and they ended up being my references when I applied for Canadian citizenship in 2007. In the end, I told them all about my initial suspicions, and we still have a good laugh about it whenever it comes up. They are good friends, even though I never joined their congregation.

My soccer academy was now thriving and I was landing more and more contracts and developing a good reputation as a professional community coach. I was coaching children, youth and adults on community centre teams and for other clubs, and training parents as volunteer coaches. People in the community, children and moms and dads were supportive of

what I was doing, but I was always emotionally detached from them. I suspected some of them might be spying on me. I made sure to find out exactly who they were. Even if I knew them well, I still didn't give anyone the benefit of the doubt, I kept my distance. Whenever people asked me about Hutu and Tutsi or anything about Rwanda, I would be deeply upset and deflect their questions. I declined business contracts with anyone who wanted to talk about Rwanda or knew something about it. I easily lost my focus in those days, and couldn't handle too many clients. Nor did I want to invest too much in my business, in case my Canadian citizenship was denied. I was obsessed with getting citizenship. I couldn't invest myself fully in my new life until I knew the final outcome.

From 2001 to 2005 I pushed the Immigration Department to clarify my citizenship status, but I got nothing from them. I finally wrote an impassioned and angry letter telling them that I urgently needed a response about my application. I called in and tore into one of the immigration officers, Madame Lozon, and with our conversation being in French, I was able to express my anger very well. She finally told me that my file was no longer with her, but was now with the Canadian War Crimes Investigation department in Ottawa. Soon after that, in February 2005, a business card from an officer at the Surrey RCMP headquarters was left on my porch, requesting that I call him. When I saw this, I started to panic. I imagined he wanted to detain and arrest me. When I called him, he told me that I had to be at Vancouver RCMP headquarters to meet with officers from Ottawa on the following Wednesday at 10 am. He gave me no reason for the meeting but I assumed he was just a liaison and probably didn't know himself. I was afraid, but at the same time relieved that finally I would learn the exact nature of the allegations against me, and get a chance to tell my story. I

wanted everything out in the open, even though it might lead to my arrest.

On the appointed Wednesday I showed up at 9:45 in the morning at Vancouver RCMP Headquarters. I told the duty officer that I had an appointment with members from Ottawa. He had no idea what I was talking about, and asked me their names, which I didn't have. Just then an officer in a blue suit and blue tie came up behind him at the window, and told me I was his client. I suspected he had pictures of me and thus was able to identify me without asking my name, and that turned out to be true; in fact, I would soon find they had extensive information on me.

The officer led me to an office where another plainclothes officer was waiting. I sat down, and they introduced themselves as Sergeant Guy Poudrier and Corporal Richard E. Dupas. They were from the Ottawa War Crimes Investigations Section of the RCMP, and they were in Vancouver to talk to me about allegations forwarded to the Canadian government by the government of Rwanda.

After confirming my identity, they told me that I wasn't under arrest, and that this was an open investigation. They told me I had the right to seek legal counsel, and they gave me a 1-800 number I was to call before they could proceed. When I called the number, I got a female lawyer on the line with a beautiful voice; I explained to her that I was under investigation by the RCMP War Crime Investigators in relation to allegations of genocide in Rwanda. After hearing my brief account over the phone, she suggested that I not talk to them until I had retained a lawyer. I asked her if she could represent me, and she said no, she was online support in Victoria, and I'd have to find my own lawyer in Vancouver.

I thanked her for her help, and went back to the office where Sergeant Poudrier and Corporal Dupas were already closing their files and packing up their video equipment, having assumed that I wouldn't talk to them before retaining legal counsel. Sergeant Poudrier asked me how I wanted to proceed. I told him: "I have been waiting for you to come and ask me to tell my story for seven years. I don't need a lawyer. I'm ready to tell you everything now, and if there's a need for a lawyer, I will retain one afterwards. I'm ready to answer any questions you may have." The two officers were surprised and even seemed shocked. They thanked me for my openness. My approach to the situation was clearly not at all what they expected after investigating other Rwandans and others accused of war crimes.

I had been traumatized by this case for 11 years, ever since learning of the infamous génocidaires' list in August 1994 in the Congo. I wanted to get it over with. I knew the allegations had to be false. I also understood that these types of allegations usually require legal advice. But bringing in a lawyer may have delayed my case further, and I knew my story better than any defense lawyer ever would. I was confident that after I had told my story, the absurdity of the allegations would be clear. I knew as well from my own experience that lawyers can be very calculating, and drag out a case to maximize their fees. And I kept in mind the case of Rwandan Hutu Prime Minister Jean Kambanda, who was led by incompetent legal counsel to plead guilty to a charge of genocide in 1998. I felt my testimony would speak for itself. The interrogation took just over 6 hours. I was given the choice of conducting the interview in French or in English, and chose French, which would be much more comfortable and efficient for me. Both officers were fluent in French.

They started by informing me that at the time when I landed in Canada in 1998, the Togolese government had

already received an International Arrest Warrant issued by the Government of Rwanda through Hutu Minister of Justice Nkubito. The Government of Togo had then forwarded the International Arrest Warrant to Citizenship and Immigration Canada. The two officers showed me the Rwandan arrest warrant but did not give me a copy. Sergeant Poudrier next said that they needed to determine whether I had committed crimes against humanity under the International War Crimes Convention, and hence, prosecutable under the Canadian Crimes Against Humanity and War Crimes Act enacted in 2000.

Sergeant Guy Poudrier had been tasked with the investigation of Rwandans in Canada accused of war crimes starting in 1994, and had made several trips to Rwanda to conduct investigations. He was quite familiar with the culture and history of Rwanda and seemed to be able to understand some phrases in Kinyarwanda. I thought he had a better chance than most people of grasping the complexities of my case.

The International Arrest Warrant issued by the Rwandan Minister of Justice can be summarized as follows:

1. While working at Radio Rwanda between April 06 and July 04, 1994, I had broadcast messages urging Hutu militia and peasants to massacre Tutsi and moderate Hutu;

2. And I was a founding member of Radio Télévision Libre des Milles Collines (RTLM), whose broadcasting of messages of hatred against Tutsi constituted a war crime, a crime against humanity, and a crime of genocide;

3. My origin in Northern Rwanda in the province of Ruhengeri suggested that I must be part of President Habyarimana's inner circle, and guilty by association

of planning and perpetrating the crime of genocide; my trips to Europe to study television production were further evidence of this privileged position with the Hutu government of the day;

4. Being under International Arrest Warrant through Interpol, and having come to Canada as a Landed Immigrant, I must have lied to Immigration in Canada and told them I was not wanted on any international charges. Because I had lied, I should be ineligible for refugee status in Canada and subject to deportation in accordance with the Immigration and Refugee Protection Act of 2001.

After having the allegations read to me by Sergeant Poudrier, I felt elated. I was sure I could make short work of these baseless and manufactured charges. The Sergeant had laid out a list of questions for me and we worked through them systematically. He was consistently professional in his approach, and the questionnaire seemed very well-designed. During the next six hours, they would fill three audiotapes with my statements and their questions.

Every time a tape was finished, they would stop the interrogation and start again with a fresh tape. I was impressed at how well-organized and humane their interrogation was. It did not resemble any interrogation I'd ever heard of in Rwanda or in any African country. They made no attempt to intimidate me, and showed no signs of bias in their words or their behaviour. Most amazingly to me, there were no threats, hints or mention of torture. They brought me a sandwich at lunchtime, which kept my energy up and my mind clear. If they had been any nicer to me, I would have suspected them of poisoning the sandwich! In Rwanda, we always think the government is on a mission to kill us, which is true much of

the time, and certainly true under the present government of Paul Kagame.

As we saw it, there were four primary allegations. The first was that I had been broadcasting hatred at Radio Rwanda in Kigali, from April 6th 1994 until July 4th 1994, when the RPF rebels took Kigali, the capital city. I explained that I had been at Mudende University in Gisenyi Province, 153 kilometres away. I had been saving Tutsi and Hutu students from the murderous militia and peasants at Mudende University, and after that I had been in Gisenyi City. I gave the investigators dates, places, and times, as well as the names of Hutu and Tutsi Rwandans, Belgians, and Americans who could testify that I was not in Kigali, but only in Gisenyi.

The second allegation was that I was a founding member of Radio Télévision Libre des Milles Collines (RTLM). I said to the war crimes investigators that, when I had gone to study television in Belgium, I had an overwhelming passion for television in general with a dream of being a pioneer in Rwandan television. When the RTLM, the first commercial television enterprise in Rwanda, was created, I jumped at the opportunity to buy a share for 5,000 Rwandan Francs – about 70 or 80 Canadian dollars at the time. I had already launched my own small audio-video production company in Kigali. Many Rwandans bought a single share or more; RTLM shareholders included Hutu, Tutsi, politicians, business people, military officers, and civil servants from the North, East, South, and West of Rwanda. I gave the officers names of prominent officials in Kagame's government who were RTLM shareholders. This allegation was meaningless, and of course my interrogators could see that.

The third ridiculous charge was that my birth origin in Ruhengeri in the North, and the fact that I had studied television and traveled abroad, implied that I was part of

President Habyarimana's inner circle. I told the officers I hadn't chosen to be born in Ruhengeri, and, to be frank, if I had had any choice as to my birthplace, I would rather have been born in Vancouver, Geneva or perhaps Bordeaux. Second, my opportunity to study television in Belgium had been the result of hard work, persistence, and talent. I hadn't been selected because of some mythical connection to Habyarimana's inner circle; I had competed against 600 other applicants in national television technical and theoretical tests and gone through the entire interview process in Kigali, and finished among the top 25. I told the officers all those records would be available at Rwanda National Television as well as at the Belgian Francophone and Flemish National Television services in Brussels. Rather than a reward for political connections, my European study opportunities had resulted from my methodically written and competitive applications that, ironically, had been approved, not by the Rwandan government but by the receiving European institutions. I told them that if they were to verify my grades with the Belgian national television records, they would find I had finished my course of study with the highest score of any student. Though they didn't say so, I could tell that my interrogators knew this allegation was nonsense as well.

The fourth accusation was that I had violated the 1951 Geneva Convention's Refugee Protection Protocols and lied to the Canadian Ministry of Immigration. I told the officers that I had fled the Tutsi government solely because I had been targeted to be killed as a Hutu, and for no other reason. The context for this claim was that the Tutsi government had followed the fleeing Hutu into the Congo, and committed the 1996 Rwandan Hutu genocide in that country, a genocide that was still going on. I provided details to the investigators on 54 ministers, generals and prominent Hutu politicians who had joined the Tutsi RPF government after the 1994 Tutsi

Genocide, and who had then been forced to flee Kagame's killing machine. My immigration to Canada had been legal and my landed immigrant status in Canada had been processed correctly. I had never been informed of any charges, or of any international arrest warrant issued against me.

At 4:15, the interrogation was complete. I felt I had presented my case well. Sergeant Poudrier remarked that from what I had told them, and from his knowledge of Rwandan affairs acquired through numerous investigations, my story had the ring of truth, and it appeared I was a victim of political conspiracy and propaganda. To wrap up, he asked me to prepare for him a list of the names and contact information of 50 to 100 Rwandans and others who could verify elements of my story. I was to send him these names and supporting documents so that he could complete the investigation. He also told me he was heading back to Rwanda soon and would be able to verify some of my sources directly.

I could see that the investigators' reactions to me had shifted. The interview had not gone as they expected. I imagined they would not be happy that Canada had carried out such a substantial investigation based on such flimsy allegations, an investigation that must have cost taxpayers hundreds of thousands of dollars. I wonder now how much the Canadian Government spends yearly investigating the multitude of cases initiated by corrupt and devious governments like that of Rwanda.

After the interview, I headed to the West Point Grey Soccer Club to coach the 12-year-old boys' team. I was late, and my co-coach of three years, a parent volunteer, Brian Oates, was surprised; I'd never been late before. Brian asked me what had happened, and was curious about my arriving in my grey suit before changing into my track suit, another first. I told him I was coming from an important job interview. I wasn't about to share anything about the charges and interview. I felt that too

many people were in my head and probing at me. That was my state of mind for all those 9 years.

In the meantime, I suspected my other parent co-coach, Bob, might be a spy who was assigned to watch me. One day he had told me he was working a night shift, and from that I hypothesized he might be a police officer. I was manic about finding out as much as I could about everyone around me, obsessed with avoiding being spied on, determined not to disclose much information about myself. When the soccer practice ended, I felt relieved no one had caught onto where I'd really been that day. Recently, Bob told me that he works in the fishing industry, and when I told him and my family doctor of 20 years about my suspicions back in 2005, they both laughed. They could not comprehend the magnitude of the danger I was facing. Perhaps after reading this book, they will understand.

That evening and into the night, I made phone calls to friends in Rwanda, Kenya, Belgium, Netherlands, Switzerland, France, the United Kingdom, the United States, and across Canada, asking them to be witnesses on my behalf. I started organizing their contact information as requested by the investigators. I was excited and anxious, totally unable to sleep. I wanted this investigation to be completed immediately. Sergeant Poudrier had told me to get this done as soon as possible, and I went at it with a vengeance. Among the 64 people that I called, only two declined, one of the two, Isidore, probably out of fear of reprisals by the Rwandan government, and just not wishing to have anything more to do with the world of war crimes, crime against the peace, crimes against humanity, genocide and Paul Kagame.

After submitting all the requested information by mail, I waited six months without any whisper of a response. I waited until a whole year had passed, and finally worked up the courage to call. Sgt. Guy Poudrier had told me he would need time to

investigate all the given information, and would be travelling to Rwanda and Europe, but I was not willing to let things drag on indefinitely with no communication. The media were increasingly full of stories about Rwandans accused and tried in Western countries, and I didn't want to find myself there alongside them.

There was an ongoing international criminal case in the UK concerning four Rwandans accused of war crimes and genocide. This case was broadcast internationally, and there were different opinions about what the outcome would be. Some journalists and commentators thought they would be extradited back to Rwanda, and others that they would be sent to the International Criminal Tribunal for Rwanda, ICTR, in Arusha, Tanzania. There seemed a faint possibility they might be acquitted under human rights provisions that had been in force in the UK constitution since 1998. I followed this case closely, as it might set a precedent for cases like my own in Canada. The hearings seemed to go on forever, but the amazing outcome was that the men were acquitted, and given the right and freedom to remain in the UK. The case served as an excellent example of how Rwandan war crime allegations could be filled with misinformation and lies, and would help my case because it set a precedent that Western courts could examine.

Then there was the case of *Mugesera v. Canada* that started in 2005, the year of my RCMP interview. It was a long and tangled legal saga; Dr. Leo Mugesera would spend in total almost seventeen years fighting to remain in Canada. A university professor and politician, he was accused of broadcasting hate speech against Tutsi in Gisenyi in November 1992, before fleeing to Canada in the same year. It was believed that he had invited Hutu to kill Tutsi under the guise of "sending them back to Ethiopia across the Nile River." This case provided me with a constant irritant, as Canadian friends would ask questions

about Mugesera's case every time it resurfaced in the media. I was constantly afraid that, sooner or later, my saga would grace the media as well, based on the same kinds of false allegations. The messages that Mugesera promulgated in 1992 were not very different from what the RPF's radio station Muhabura had been broadcasting against Hutu, but of course justice was only available to the winners of the war. The knowledge that I might soon land on the same accused bench as Mugesera, labelled as a perpetrator of the genocide, fed my anxieties and fears. I had always been fearful of my image being tarnished, and now I was exhibiting full-blown symptoms of PTSD[28].

The very worst Rwandan-Canadian case was that of *Regina vs Munyaneza*. Desire Munyaneza was a Rwandan who had been accused of rape and other war crimes, crimes against humanity and genocide. He had been living in Toronto and was tried in Montréal. This case was widely broadcast on Canadian radio and television, as well as in the newspapers. In Canada, people stay connected through the news media; it's very different from Rwanda where everyone knows everyone else and we learn everything from our networks. I was asked about the Munyaneza case frequently by people I knew, and I knew a lot of people. I was working with more than ten soccer teams, and meeting with two hundred or more parents weekly. Things were getting out of control.

The worst part about the Munyaneza case was that Sergeant Guy Poudrier, who was handling my case for the RCMP, was also investigating Munyaneza, and making multiple trips to Rwanda where he dealt with both our cases simultaneously. In my interrogation he had pointedly asked me if I knew Munyaneza, which I didn't.

[28] Post-traumatic Stress Disorder.

All of these cases perpetuated my fear that my case would ultimately get media coverage nationally and internationally. Over 5,000 Canadians, toddlers, children, men, and women would hear that their coach, teacher, mentor, leader and role model was a "*génocidaire*." I had built strong ties in my community, and my worst fear was that these would disintegrate, leaving an image of me as a mass murderer in everyone's minds, including those of my own children.

Making things even worse was the release of the movie *Hotel Rwanda*[29], the story of Paul Rusesabagina who saved lives of Tutsi and Hutu who sought refuge in the Hotel Des Milles Collines in Kigali during the 1994 genocide. When it came out, Canadian friends kept asking if I'd like to go see it with them. I told some I would go, thinking it would give me an opportunity to explain about Rwanda's tragedy. I told others I had already seen it, which was not true. I knew Paul Rusesabagina, and I'd read his book, *An Ordinary Man: An Autobiography, 2006,* but felt it was biased and inaccurate. However, when I did finally see the movie with friends, I found that the depiction of relations between Hutu and Tutsi was accurate and true to life; the movie didn't show any dramatic ethnic conflict between Hutu and Tutsi. This pleased me very much. It meant that I didn't have to explain the genocide to my friends in any depth. Most remarkably, the film didn't blame Hutu for everything as had General Roméo Dallaire in his well-publicized book.

Shake Hands with the Devil: The Failure of Humanity in Rwanda was published in 2003, by Canadian retired Lieutenant-General,

[29] Hotel Rwanda is a film aired in 2005 about the 1994 Tutsi genocide. As a Belgian Mille Collines hotel manager in Kigali, Paul Rusesabagina used his power and influence to personally save Tutsi and Hutu refugees. Rusesabagina regularly bribed Rwandan Hutu soldiers and kept militiamen outside of the hotel property for 100 days of murder.

Roméo Dallaire who had a part in the Rwandan tragedy. In his book and public speaking engagements, he blamed the Hutu ethnic group exclusively for the genocide of 1994, and ignored altogether the genocide of 1996 committed by the Tutsi army. Dallaire's frustration and anger against *Hutu Power* extremist Colonel Bagosora and Hutu militia led him to believe that all Hutu were perpetrators and that the Tutsi RPF somehow deserved to win the war. This bias was exacerbated by the massacre of UN Peacekeepers by Hutu in the FAR.

In my view, Dallaire's book reveals his critical lack of knowledge of Africans and the anthropology of the land in Rwanda[30], as well as a fatal shortage of experience in international peacekeeping and diplomatic relations. It was not diabolical Hutu who engineered his failure; he manufactured it himself. The book is filled with misinformation from his key informants, manipulative Rwandan politicians like Faustin Twagiramungu.[31] Even more damaging, the book was the first one written on the 1994 Rwanda genocide and became a bestseller; it undermined the Hutu's position and guaranteed their human rights would be violated both inside Rwanda and in the Diaspora for a decade or more. The presence of his book in Canadian libraries and homes made me anxious

[30] *Anthropology of the land* is a methodology advocated by African anthropologists and Africanists which consists in knowing African cultures and needs before you help or cooperate with Africans instead of imposing development or advice. Failure to apply this approach has resulted in resistance to change and boycotting of imported ideas, infrastructure and development projects.

[31] Faustin Twagiramungu is a Rwandan Hutu politician who served as Prime Minister for 8 months during the first RPF government. Motivated by political ambitions, he had given UN Peacekeeping commander General Dallaire misinformation and induced him to make flawed decisions that plunged Rwanda into chaos and genocide.

and at the same time angry, as he repeated apocryphal stories and presented deeply flawed analyses. Today, his narrative and analysis have been sharply questioned and cast in doubt by a variety of journalists and researchers. Current work that provides a different perspective includes the BBC 2014 documentary, *Rwanda's Untold Story*, by French investigative journalist Charles Onana, additional work by human rights activist Allison Desforges, by Dallaire's boss, Jacques-Roger Booh Booh, in his book, *Le patron de Dallaire parle: Révélations sur les dérives d'un général de l'ONU au Rwanda*, and most notably by Montreal writer Robin Philpot, too, in *Ça ne s'est pas passé comme ça à Kigali*, known also as *Rwanda 1994: Colonialism dies hard* in its English translation. It is encouraging to see others working so hard to dispel the faulty information that has circulated for so many years.

I hope to have an occasion to discuss it with Dallaire one day. His failed leadership of the UN Peacekeepers in Rwanda, and his credulous acceptance of the RPF narrative, helped plunge Rwanda into its current state of authoritarian misery. The first and last time that I came face to face with General Dallaire was on August 19, 1993 at the Kigali Grégoire Kayibanda International Airport. I was part of a Rwandan media team that covered his arrival when he came to inspect the territory and make his first contacts with Rwandan authorities, including President Habyarimana, Hutu and Tutsi opposition leaders, Tutsi RPF insurgency leaders, and others interested in the Rwandan civil war and conflict in the African region. After interviewing him, we liked him as a Canadian gentleman, but he did not give us the impression that he was a real soldier who would do a good job in that critical context. We knew the game between the shrewd RPF and the aggressive FAR very well, and we knew how to read the face of the naïve and inexperienced UN soldier in front of us.

Dallaire divided Hutu and Tutsi and did nothing to reconcile their interests or bring them together. Twenty years later, the BBC's documentary is a great relief for many Rwandan Hutu. It casts a new light on Dallaire's simple-minded praise for the Tutsi RPF and Paul Kagame, who ignited the Tutsi genocide and in doing so dug the graves of hundreds of thousands of Tutsi in order to realize his own political ambitions.[32]

After my interrogation with the RCMP investigators, I still had to wait for the completion of the second step of the investigation, which they had told me would take at least six months. After eight years of waiting, I knew that the end was in sight. My business, education, and other aspirations had all been put on hold by the shadow hanging over my immigration status, and I was hoping I would soon be able to pick up all these threads and move on. Though I was less stressed now than I had been before the interrogation, I didn't change my guarded behaviour and still kept a very low profile, not telling my life story to anybody. I knew the investigation was now in its critical phase.

I had told the RCMP my story and assumed that this would put their investigation well on its way. I could see things going one of two ways: either there would be more interrogations, possibly followed by a criminal court hearing, or perhaps there was a slim chance I might be cleared for citizenship without any further interrogation. I felt relieved because I had had the opportunity to tell my story, but I was angry that it had taken so long to get to this point. When I came to Canada in 1998, I had a road map in my mind, and I was expecting success to come quickly as it had in Belgium and Rwanda. I had international experience, a BA and an MA and 2 diplomas; I was highly fluent in French, and in my view I was well equipped to take off on a career path of my choosing in Canada.

[32] See the BBC video at https://vimeo.com/107867605

This interrogation took place in February 2005 and by the end of June, 2007 I couldn't wait any longer. I called Sergeant Poudrier in Ottawa and asked him about the progress on my case. He was surprised that I hadn't been informed about anything; he had completed the investigation a year earlier, in June 2006, and had sent his final report to Citizenship and Immigration. He told me the outcome had been in my favour and I could rest easy, and then added, in French, *"Tu peux dormir sur tes deux oreilles."* In my agitated frame of mind I misunderstood this expression, which means 'you can rest easy,' and thought he meant he wasn't sure there was a positive outcome. Before he rang off, he gave me the name of a person to follow up with at Immigration.

I called Immigration immediately after hanging up, but they couldn't connect me to the man I was looking for, Mr. Tucci, in the Ottawa office. Then I called Madame Lozon at the New Brunswick office, with whom I had been dealing for the past 8 years. She didn't have my file, but she could see through the system that the clearance had been completed. The file was with the Immigration Office in Ottawa. I blew my top at her, quite unfairly, but I couldn't help it. She apologized and told me it was unfortunate that I'd had to wait that long, but that there was nothing much that she could have done. Realistically, I knew she didn't have any role in the investigation or in my clearance. And government is government after all; it's the fate of immigrants and refugees to wait years while bureaucratic wheels grind slowly, or stop grinding altogether.

Chapter 10

GETTING CANADIAN CITIZENSHIP

I HAD BEEN ASKED TO submit my criminal record check, fingerprints and new photographs to a Canadian Immigration Office in Ottawa. I thought they wanted this either because they planned to arrest me, or because they were going to hand it all over to CSIS, who would then be able to follow my every move. I sent off the documents, and kept watching my back everywhere I went.

Early in September 2007 I received a letter from the Immigration office giving me a time and date to take the Canadian Citizenship test. I dragged myself there and took the test. I was informed I had passed it, as people generally do, but in my state of mind at the time, I didn't take this as any kind of guarantee that I'd get my citizenship. In my worst moments, I imagined it was all a game, and that once D-Day came, they would arrest me and put me on TV as a Rwandan mass murderer. I trusted nothing that came from the Canadian government.

Not long after the test, I got a letter inviting me to take the oath of citizenship at a Citizenship Ceremony on October 12, 2007. I read it over and over, dozens of times. I didn't know if it was real or a fake. I examined it in minute detail to see if it really looked like an official document. I called Citizenship and Immigration to verify its validity. I told absolutely no one about it; I thought they might still revoke it at the last minute.

My family and I showed up on October 12 at Citizenship and Immigration Canada's offices at 877 Expo Boulevard in Vancouver, in the Province of British Columbia, where the ceremony was to take place. When I asked the commissioner if my name was on the list, he confirmed that it was. Up until that moment, I had kept thinking that this was the day when I would be arrested. I had never allowed myself to believe in a positive outcome.

I went in and waited with Christine and my daughter Clary, who were also there to be sworn in as citizens, and with my youngest child, Izzy, who had been born in Canada and therefore had received Canadian citizenship. After what seemed a very long wait, an immigration officer called all the citizenship candidates' names, and handed each one in turn his or her citizenship certificate. Now I had my certificate in my hands. Everyone around me was happy and rejoicing, but I felt only confusion. I kept looking at the beautiful certificate, but I felt no emotion at all. Some people stayed for soft drinks and socializing, but I quickly left, pulling my family along, and drove away. My happiness started to break through when I was driving home; I finally realized I had become a Canadian citizen. That whole afternoon I was gloriously happy. I changed into the clothes I had planned to wear for this day, years before, when I had thought I would get my citizenship in 2001, in the normal time frame of 3 years after landing in Canada.

I had arrived in Canada as a Landed Immigrant in 1998. I had come strictly through the front door, fulfilling every requirement meticulously. I had not sneaked in as a spurious refugee claimant, nor been smuggled in by "coyotes" or "snakeheads." I had done everything according to my own values. Now it was 2007. Other Rwandans who arrived in the same time frame and under the same circumstances became Canadian citizens as early as 2001. One Rwandan acquaintance of mine, Festus Kiragi, settled in Vancouver in 1998, and got his citizenship in 2002. Another, Claudien Magambo, entered Canada from the US in 1999 and became a refugee claimant, and used to boast about how lucky he'd been to get his Canadian citizenship before me, given that he'd entered the country through the back door. I didn't resent Claudien's easy success, and indeed I congratulated him on his luck.

I decided to put all my frustration and bitterness behind me, and give myself a fresh start. I wanted to live as if I had just come to Canada on that very day, October 12th, 2007. Even today, I still think of myself as having only been in Canada since 2007. I made a decision to try to erase the traumatic memories of the previous nine years from my memory, and much of the time, that has worked well for me.

Chapter 11

FREEDOM FOR TRAVELING, DETENTION, AND ARREST

I HAD BEEN BLAMING EVERYTHING on the circumstances of my citizenship struggle. I blamed the loss of my modest 20-foot container of second hand clothing in Lusaka on my inability to travel, instead of on my own naiveté in trusting my Rwandan employee in Zambia, and on my lack of judgment in business. Losing $20,000 USD so foolishly was like a kick in the head, but I came to value it as a wake-up call. I had to take responsibility for my own fate before I could move ahead.

I came to understand that, though my parents had taught me the value of hard work, studiousness, and kindness to others, they had neglected to tell me and my siblings that there was a point where being too nice could make you easy prey for swindlers. They were optimistic and positive people who raised four children, worked hard, and did very well for themselves.

They didn't teach us about the scammers and crooks of the world. And so, I would have to learn my lessons about the dishonesty of others from the school of hard knocks.

By this point I had been like a prisoner in Canada for years, and I was eager to get out into the world. To regain my confidence, I first took a trip to Ottawa, the capital city of Canada, in November of 2007. I loved Ottawa despite the cold weather, and I wanted to take a look at the University of Ottawa; I had submitted an application for their Law School. I desperately wanted to get back to university to resume my studies. I also wanted this opportunity to visit long-time Rwandan friends in Gatineau, just across the river in the province of Québec.

In the Capital, many people speak both French and English fluently, including immigrants from Europe, the Middle East and Latin America. This is in strong contrast to Vancouver, where you rarely meet people who are fluent in French. Why had I not considered moving there earlier? The RCMP had asked me the same question during my interrogation. Generally, people I met in Ottawa were quite open and willing to talk to strangers. I felt welcome in the city and my French and English helped me connect well with people. It was a great first trip for me as a Canadian.

After 10 years of isolation in Vancouver, I was really out of touch in a number of ways. Things had changed around me, and the 1990's suitcase I was dragging around looked quite odd in 2007. Everyone around me in the airports had suitcases with wheels and telescoping handles, and I was carrying my old, heavy bag. Some passengers joked about my nice light suitcase, and I told them it was an antique I'd bought in a museum back home in Africa.

On my way back, at the Vancouver International airport, a security officer at the baggage carousel approached me and asked

me to show him my ID while I was retrieving my unique old-fashioned suitcase. I've never heard of any passenger being asked to show their ID in Vancouver in the baggage area; it just didn't happen. I was shocked and he looked a bit embarrassed; I think he realized he was on thin ice. Perhaps he'd assumed from my old and cheap luggage that I might be a new refugee claimant, or some sort of illegal immigrant, or a local undesirable. When he saw from my documents that I was a Canadian citizen and lived in Vancouver, he looked sheepish. As I looked at him and considered whether I should ask him why he'd singled me out, he quickly moved away, saying "Sorry..." as Canadians do in any situation where they have intruded into someone's space or someone has intruded into theirs, no matter who is at fault. I read him as a newly-trained agent applying his profiling checklists, and finding out they didn't work as well in real life as they had in his training.

None of this affected me, though. The trip to Ottawa had been a very good one for me. Now, I was a free man, with the freedom to travel. I quickly bought a ticket for Europe –to England, and then Sweden. I had two compelling reasons to take this trip. First, I had lived in Belgium and France, and there were many Rwandan and European friends there that I hadn't seen for years and years – people who'd helped me as I struggled to survive in exile in Africa. As well, I wanted to investigate the annual Youth Soccer World Cup in Gothenburg, Sweden, to see if I could take Canadian soccer teams from my academy to compete there.

On December 15, I landed at Heathrow International Airport in London at 7:30 a.m., with my brand-new rolling suitcase that was guaranteed to raise no suspicions at customs. I was planning to stay for 4 days in London and visit my numerous relatives and friends there. I was anticipating that this would be a very pleasurable four days indeed.

I collected my baggage from the carousel and headed to customs. When I got to the head of the line, I handed over my Canadian passport to the immigration officer at desk #4. He greeted me cordially and said, "Welcome to London!" He scanned my passport, and suddenly on his screen, a notification popped up.

He read the notification, looked at me very appraisingly, and said "You have to come over to this side because there is something we have to ask you." He logged out of his computer and placed a 'Closed' sign on his counter. As I stepped through the gate to the other side of the counter, I told him, "Don't worry, I understand what's going on." When he asked me what I thought it was, I told him very openly and clearly that my name was in Interpol's database because there were allegations of war crimes, crimes against humanity, and the crime of genocide; allegations that had been manufactured by the Rwandan government.

He thanked me, and called airport security. A security officer quickly arrived and asked me to bring my suitcase and follow both of them to an office on the next floor. They told me they had some questions for me. There were 11 questions: "Where are you going? Are you carrying any illegal drugs? Do you know that it is illegal to carry drugs? Did anyone force you to bring anything with you? What's your purpose in going to Sweden? How much money do you have with you? Where are going to stay in London? Do you have a credit card? How long have you been in Canada? What do you do? Do you own this soccer school? Do you have an invitation to come to London?"

After all these questions, they searched my luggage thoroughly. Then we headed to the airport detaining room. According to the Notice to Detainees that they gave to me, I was Detained and Arrested by the Home Office under paragraphs 16 and 17 of Schedule 2 of the Immigration Act of 1971, and the Immigration and Asylum Act of 2002. It was 11:40 a.m.

The detention facility at Heathrow airport was a big room, with a small television screen, six hard plastic chairs, two long plastic tables, a garbage can, a shelf with a couple of dozen ancient paperbacks, a telephone booth, and a washroom each for men and women. Detainees slept on the chairs or on the table. When I arrived, I found my fellow detainees were a woman who said she had come from India, and a mixed-race man from South Africa. They said they had been there for 2 and 3 days respectively. The Indian woman had entered the UK illegally, and the South African was waiting to be deported. As for me, I was waiting for my interrogation so that I could recite my well-rehearsed narrative in respect to the trumped-up charges, and then ask to be put back on the earliest Air Canada flight to my beautiful Province of British Columbia. My experience here was not living up to the guarantees in my beautiful Canadian passport which states:

CANADA

The Minister of Foreign Affairs of Canada requests, in the name of Her Majesty the Queen, all those whom it may concern to allow the bearer to pass freely without let or hindrance and to afford the bearer such assistance and protection as may be necessary.

Le ministre des Affaires étrangères du Canada, au nom de Sa Majesté la Reine, prie les autorités intéressées de bien vouloir accorder libre passage au titulaire de ce passeport, de même que l'aide et la protection dont il aurait besoin.

THIS PASSPORT IS THE PROPERTY OF THE GOVERNMENT OF CANADA

CE PASSEPORT EST LA PROPRIÉTÉ DU GOUVERNEMENT DU CANADA

I much appreciated the diligence of the Canadian Foreign Minister and the Government of Canada in appealing for my protection to the Queen. Unfortunately, the Home Office breached my rights that were guaranteed through the United Kingdom Royal Prerogatives under the Cabinet's collective responsibility. It would be fair to say that the Home Office acted *ultra vires*[33] and that my rights should have been restored. I have initiated a claim against the UK Home Office concerning this abuse of power, which occurred under Prime Minister Tony Blair, who is today the unpaid personal advisor of Rwandan President Paul Kagame, preaching democracy on the world stage, but counselling tyranny in Rwanda.

The cell had a large window through which we could see the four uniformed men on duty in the security office. It had been many hours since I'd had anything to eat or drink. When I first got to the cell, they had offered me a meal, but I said I didn't want it. I had been just too angry to take anything from them. However, I forced myself to keep a façade of politeness; I knew from experience that anger doesn't work well with police or security officers, who expect deference from presumed wrongdoers. I knocked on the window, and I asked if I could get a local newspaper and a calling card to call my Rwandan relatives and friends, who were at the airport waiting for me and had no clue what had happened to me.

The guards gave me the newspaper that I had asked for to keep my brain busy, but they said they couldn't give me a telephone calling card, and that I would have to pay for that myself. I told them my money was locked in their office, and requested they go into my wallet and get out enough cash for me to buy a calling card. They said they were sorry, but they couldn't do that. I went back to reading the newspaper, but I was steaming. Ten minutes passed, and I went back to knock

[33] Ultra vires: that which is beyond one's legal power or authority

on the window again, and I told them I suggested that if they didn't bring me a calling card right away, they were going to lose their jobs. They finally went and got one for me and told me that I would have to pay them back. I assured them that the money was not a problem.

Unfortunately, all of this occurred on a Saturday. This meant I couldn't call the Canadian High Commission, nor were there many officers present to interrogate detainees. I started to panic, thinking I might not get a chance to explain my case until everyone left for the day, and then would be stuck there for the entire weekend.

Around 12:45 p.m., an Immigration Officer came in and took me to his office. He started by apologizing for not having someone in the area; he explained that this was because it was the weekend. I thought to myself, *aha, that's why this detention has gone on so long that it's now become an illegal detention.* He brought out a pile of photographs and information extracted from various websites, and started to interrogate me. I stopped him in order to keep him from wasting his time, and mine as well. I gave him a fast history of the Rwandan Tutsi-Hutu conflict, the allegations against me, and how the Canadian War Crimes Investigation Section and the Canadian Ministry of Citizenship and Immigration had taken almost ten years clearing me by undertaking investigations in Rwanda, Canada and the UK. I showed him my Soccer Academy website so he could see what I did in Canada, so he wouldn't need to fish for information about my life. I didn't want him to waste my time with speculation that might justify their illegally detaining me under their Immigration Act. I gave him the names and contact information of the Canadian RCMP officers who had investigated my case.

After I explained all this, he showed me some photographs of people he identified as Rwandan war criminals who had

allegedly participated in the 1994 genocide, and asked if any of them were me. I looked at the pictures, and told him with all the restraint I could muster that they were neither of me, nor my father nor any of my relatives. After they concluded the interrogation, the officer and his assistants seemed convinced by my story. They told me I would be granted a 6-month visa for the United Kingdom. The officer told me, however, that as I was still being flagged by Interpol, I needed to be aware that I could possibly be arrested again within the UK or in any European country. Shocked and upset, I responded with an expletive, unmitigated by my usual restraint. I had been traumatized by these allegations for the previous 13 years, and then had thought I was finally free of them, and now the whole mess was following me again. It was infuriating and intensely frustrating. After a deep breath, I thanked the officers, and asked them where I should go now. One of them escorted me out to public transit. From there, I called my friends, and told them that I had finally gotten out of detention. They were living in North-Western London in the neighbourhood of Camden. I didn't know anything about London's transportation system, but I was confident I wouldn't get lost. They told me to go to the Underground and take the Piccadilly Line to Kings Cross station. They would pick me up from there. Finally, at 7 p.m., they picked me up from Kings Cross, and my day of headaches and frustration had come to an end.

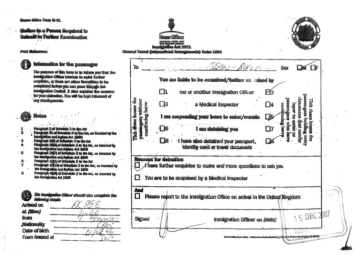

First detention at Heathrow International Airport in 2007.

My Rwandan relatives and friends gave me a guided tour of important and historical sites of London. This was my first time there, and I appreciated the opportunity to explore. First, we went to Trafalgar Square and saw Canada House, the home of the Canadian High Commission, which I had hoped would help me when I was under detention at Heathrow, but which had turned out to be closed on Saturdays. We visited Buckingham Palace and the Houses of Parliament at Westminster. I saw the BBC Broadcasting House, where two of my former Rwandan TV colleagues work, though circumstances made me reluctant to reconnect with them. I admired the beautiful architecture of London City Hall, and then we walked across London Bridge.

My friend, a Mudende University classmate, showed me many of London's historical sites. I was amazed and impressed again and again. We took the Tube to the Millennium Dome, and, at my insistence, went to see the Prime Meridian at Greenwich Observatory. I remembered learning about it

in elementary school in Rwanda, and I was excited at this opportunity to see it during my lifetime.

After those four intense days in London, I continued on with my trip to Sweden, the real goal of my trip. I flew from Stansted, a small airport 40 miles from London, to Gothenburg, the second-largest Swedish city after Stockholm. My good friend Sunkey, a classmate from Mudende University, was at the airport impatiently awaiting my arrival and eager to photograph every moment of our reunion. It had been 14 long years since we'd seen one another, and we had plenty of news and stories to share. Staying with him and his family was like a rebirth for me, as we went back in time and relived what happened at Mudende in April of 1994, when we'd last seen each other. Sunkey and his wife Jenny and I had always shared a table at the cafeteria at university; now we reminisced about the good times, but kept drifting back to the trauma and the fear we'd undergone during the massacres. From Jenny I learned that Retty had chosen to leave Rwanda and had started a new life and a family in Europe. I felt exuberant when I learned this, thinking back to her miraculous escape from the rogue soldier who blackmailed her at Mudende, and proud too, to have helped her out of that death trap.

All three of us had our own stories of narrow escapes to tell. The most fascinating episode, which Sunkey recounted to us, was at the time of the last trip to evacuate Mudende, on April 9th. He had not boarded the bus to Gisenyi on the 11th because the villagers had sworn they would blow up the bus. He exclaimed, *"Man, we walked the whole 35 kilometers to Gisenyi town on the Kigali-Gisenyi highway. Then, I was walking on the street in Gisenyi and I saw you drive up in your bus. I got on and went back to Mudende with you to pick up my bags from my room, because I hadn't been able to take much with me when we were walking. I still remember when the soldier got on the bus and wanted to kill you, and at the same*

time the villagers were threatening to blow us away with grenades. Man, I prayed to God to please tell me why the hell I had gotten on the bus after walking two days to avoid it! I was so scared that it put an image of my own death in my mind that still overwhelms me every time I think about Mudende. We barely escaped death, mon frère."

And the talk went on and on. We talked in depth, too, about Kagame's 1996 Hutu genocide in the Congo, which had swept up and killed many of the Hutu survivors of Mudende. We went on to tell each other about the struggles each of us had faced as we crossed countries and continents after our flight from Rwanda.

But the purpose of my trip to Sweden was not only to connect with old friends and tell war stories; I was also there to explore the possibility of bringing a soccer team from Canada to compete in the Youth Soccer World Tournament, for the famous Gothia Cup. I saw most of the Gothia Cup soccer fields and other facilities and talked with one of the tournament organizers, Anna, who spoke a very good English--like everyone in Gothenberg, it seemed.

Despite being detained in London, which had eroded my already somewhat fragile faith in people, I had visited old friends, seen Europe again, and learned a good deal about the Gothia Cup competitions before having my teams arrive on the ground. I put together a plan to come back and watch the tournament in 2008, and bring an Under 11 Boys and an Under 12 Girls team in 2009 and then bring Under 18 Boys in 2012. This was what I had missed for the past 10 years: the opportunity to be entrepreneurial, to get out and make my mark in the world.

After my time in Sweden, I headed back to London for another two days before returning home to Canada. Again, I had an excellent time. I wanted to watch a soccer match

and talk about it with people who were passionate about the game, so I went to a pub near my bed and breakfast, B&B, to chat with the locals. I met two Americans there, one black and one white. After watching a soccer match, we talked about American politics and the odds of Obama winning the Democratic nomination. After a very lively discussion over a drink, I convinced the two Americans that Obama would be the 44th American President. It was gratifying that I turned out to be right!

Despite the fact that I had been detained in the United Kingdom, I enjoyed my time in London very much. Back in Canada, I carried on with my 'new life' as though nothing untoward had happened. For me, gaining citizenship on October 12th represented my new start – if that was day zero, then this was now my third month in Canada. I had taken off for Europe on December 14th. This "first three months" was the time to gain momentum and start a new, vibrant life, and that is what I did.

I let the Canadian War Crimes Investigation unit in Ottawa know about my detention in London. The investigator I spoke with explained that Canada had done its part to clear me from the Canadian database, but it would be up to me to determine how to clear my name with Interpol. How would one do that, and why should I have to? I still haven't succeeded in answering these two questions.

I went back to Sweden in July 2008, as I had planned. I went this time by way of Gatwick International Airport, then on to Gothenburg. When I arrived at Gatwick airport, I was again met with detention. Fortunately, I was by myself and not traveling with any of my players, or it would have been a humiliating experience. In 2007, I had been detained for almost nine hours, and this time it would be for ten. I was detained for exactly the same reasons as before. This detention took

longer than the previous one because Gatwick security had to request my fingerprints from Heathrow to verify I was the same detainee. I was well-prepared this time, and not worried in the slightest. I knew all the routines, and I just watched TV, read the newspapers, and managed to be impeccably polite and obedient to the airport security police. I had calling cards in my pockets so that I could carry on doing business over the payphone. I was finding I could get used to any environment including detention and learn to optimize my effectiveness in it. I called people around the world, letting them know I was once again in one of London's airports, detained in respect to the same nonsensical genocide allegations that Kagame's government had propagated a decade earlier. I reassured my family in Canada and my relatives and friends in the UK and elsewhere that I was going to be okay. It would just take a bit of time to convince this new set of interrogators that I was not a war criminal, just as I had done in Lomé, in Vancouver, and at Heathrow.

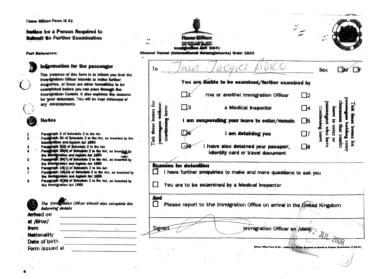

Second detention at Gatwick International Airport in 2008.

In fact, the UK Border Agency senior officer on duty that day, Rebecca Ind, entered a statement in the database that summarized the 2007 and 2008 interrogations, stating that my answers had been satisfactory, and stipulated that I could travel freely in the UK. Perhaps, after hearing my story, she could see that, instead of me being detained and interrogated, President Kagame and his cronies should be the ones to be detained, arrested and transferred to the International Criminal Court in Hague.

On my third trip to Sweden in 2009, I took a U11 (Under 11) Boys team and a U12 (Under 12) Girls team to compete in the Youth Soccer World Tournament. I advised the parents and players to travel independently for a variety of reasons, not including the real reason, which was that I was not sure what I would face at the European airports. I chose to go through Paris to avoid possible scenes in front of players and parents. I travelled with only my 12-year-old daughter, Clary. I explained to her what happened in London and told her that it could happen again entering France. I had asked my Rwandan friend Greg, who lives in France, to meet me at the airport and rescue my daughter if the French authorities decided to detain me. Fortunately, everything went perfectly at Roissy Airport in Paris. This reinforced my great affection for the French, my linguistic ancestors, as our old elementary school joke would have it.

On my fourth trip to Sweden in 2012, I had two stopovers at Heathrow, and was neither detained nor arrested. I hope the unfounded allegations that have haunted me will have been erased forever from the UK Border Agency's white screens, and that they will be eventually replaced with charges against genuine Rwandan war criminals and authors of crimes against humanity. That would seem more just to me.

It's interesting that other Rwandans have also had their difficulties at Heathrow Airport. In June of 2015, 54-year-old RPF Brigadier General Emmanuel Karenzi Karake, a Tutsi, was detained at Heathrow Airport and then arrested under an International Arrest Warrant issued by a Spanish High Court judge Fernando Andreu Merelles in a case of Universal Jurisdiction.[34] Rwandan Chief of Intelligence Karake, along with 39 other RPF Tutsi officers[35] and civilians including President Kagame, was and is still accused of killing nine Spanish humanitarian workers and two Canadian priests in Rwanda[36], as well as committing crimes against the peace, crimes against humanity, and crimes of genocide, first against

[34] Universal jurisdiction is a new concept in the international law that allows states or international organizations to claim criminal jurisdiction over an accused person regardless of where the alleged crime was committed, and regardless of the accused's nationality, country of residence, or any other relation with the prosecuting entity. Crimes prosecuted under universal jurisdiction are considered crimes against all, too serious to tolerate jurisdictional arbitrage. The concept of universal jurisdiction is therefore closely linked to the idea that some international norms are erga omnes, or owed to the entire world community, as well as the concept of jus cogens – that certain international law obligations are binding on all states.

[35] The Spanish International Arrest Warrant against RPF officers originated with Spanish High Court judge, Fernando Andreu who indicted 39 current or former Rwandan military officers, including General Kagame for crimes of genocide, human rights abuse and terrorism during the 1994-1998 when several million Rwandans and eight Spaniards died or disappeared during those tumultuous years.

[36] Two Canadian priests killed in Rwanda were Rev. Claude Simard, assassinated in 1994 after sharing his last meal with his killers, and Rev. Guy Pinard who was gunned down in front of hundreds of parishioners by a man with ties to the Rwandan military, according to an eyewitness. Sourced from: Geoffrey York and Judi River -Johannesburg and Montreal- The Globe and Mail, Published

Tutsi from his own tribe during the 1994 Tutsi genocide, and then against Hutu in the Congo in the 1996 Hutu genocide in that country. He only spent a few weeks in UK custody, and then was released on July 19, 2015, and returned to Rwanda. Knowing that his attorney in the British court was Cherie Blair, wife of former Prime Minister Tony Blair, I have often wondered if that had an impact on that unexpected outcome.

Friday, Nov.14, 2014 5:00 PM EST in "Families of two Canadian priests killed in Rwanda still wait for justice".

Chapter 12

RWANDA MY HERITAGE

I T's A FACT THAT you can choose your friends, but you cannot choose your family. My country of birth, where I enjoyed all the benefits of citizenship before becoming stateless, has a very long history of struggle between its two principal ethnic groups, with its legendary and often-repeated statistics of Hutu, at 85% of the population and Tutsi, at 14%. The 1% being the Twa. According to Rwandan oral history,[37] Hutu settlement began around the 9th century, with the Hutu organizing themselves into kingdoms under *Abahinza,* or Hutu Kings.

When the Tutsi arrived in the 11th century or thereabouts, they also quickly organized themselves in Tutsi kingdoms under kings called *Abami or* Tutsi Kings. Until the 15th century, the two communities coexisted in harmony; the Hutu lived as cultivators and small cattle herders (farming, sheep, goats, and chickens) and the Tutsi as big cattle herders (cows). There was

[37] Rwanda's oral history was not written down until after Europeans colonized Rwanda during the early 1900's.

significant economic exchange and intermarriage in many areas of Rwanda, though not in the north.

During the reign of Tutsi king Ruganzu II Ndoli in 1510-1543, Hutu- Tutsi relations broke down and the Tutsi subjugated the Hutu, in some cases through warfare and in others by manipulating those Hutu kings through their Tutsi wives. This is a simplified summary of what is told by oral tradition. Suffice it to say that the retelling of this history can be relied on to infuriate the Hutu people. After Ruganzu II Ndoli conquered the Hutu, the Tutsi reigned over their resentful Hutu subjects for almost 449 years. In 1959, when the Hutu turned the tables, their Social Revolution quickly degenerated into brutal revenge for those 400 years of slavery. Large numbers of Tutsi, including two-year-old Paul Kagame, were driven into exile in Uganda, Tanzania, Burundi and Congo. For 30 years they would suffer deprivation and discrimination in their turn, building their determination to launch the 1990 Tutsi Liberation, whose real objective was reestablishing Tutsi dominion over Hutu.

So the RPF invaded Rwanda, and mercilessly drove three million Hutus into exile, even though negotiations were underway with Uganda and the UNHCR, and meetings were planned for November 1990 to discuss how to facilitate the Ugandan exiles' peaceful return to Rwanda. The Tutsi preempted this initiative. They treated the Hutu as treacherously as the Hutu had treated them in 1959, but with new depths of viciousness.

In this historical seesaw of power, the Tutsi who remained in Rwanda after the 1959 Hutu Revolution had been reduced to second-class-citizens in what was called the "racial democracy" by the mono-ethnic Hutu government led by General Habyarimana. Those who fled Rwanda and went into exile hated the Hutu, and, as it turned out, did not care much about their fellow Tutsi who remained in Rwanda either. In the

aftermath of the 1990 Tutsi Liberation, the Hutu who remained in Rwanda were once again reduced to the status of second-class citizens, under the mono-ethnic Tutsi institutions decreed by General Kagame.

It's important to note that during the Hutu regime established after the 1959 Social Revolution, the Tutsi were subjected to sporadic killings and other humiliating treatments in reprisal for each attack launched by the Tutsi rebels, from their bases in Burundi and Uganda during the 7 years of Tutsi attacks that occurred from 1959 to 1967.

The Tutsi insurgency or rebel movement nicknamed itself INYENZI, which means *Ingangurarugo Yimeje Kuba Ingenzi* (a brave, valiant combatant), but later shifted to its negative meaning, "cockroaches," in that specific Kinyarwanda language and concept to imply quick-moving and able to hide.

From 1994 to the present, the Tutsi government has been using the Tutsi Genocide as a justification to enslave, intimidate, and kill the Hutu as it pleases. A racist narrative has emerged, purporting that every Hutu is born with a "genocidal ideology," whereas the Tutsi are angelic, born with a saviour spirit and pure hearts. Accordingly, there is political propaganda to support this discourse called *"Ndi Umunyarwanda*[38]" where every Hutu, even children born after the 1994 genocide, must apologize for crimes they have never committed.

[38] "Ndi Umunyarwanda" is a Rwandan political program that calls on all Hutu, including and especially those born after 1994, to make a mandatory and unilateral apology and plea for forgiveness to Tutsi for the sins committed by their parents and relatives in the 1994 genocide. The same apologies are not be required of Tutsi for the deaths of millions of Hutu at the hands of the RPF, both in Rwanda and in the Congo, between 1994 and 1998. It is a divisive and humiliating instrument intended to reinforce Tutsi supremacy and crush the will of the Hutu majority.

Leveraging the Tutsi 1994 genocide, the Tutsi leadership has successfully created a racist ideology that is supported by some Western leaders, including former Britain Prime Minister Tony Blair, which enables the current regime to silence the Hutu and the small minority of Twa who do not buy into the absurdity of their racial theories.

As a Hutu, I was unable to write my story and testimony for 25 years, for fear of being branded and targeted as a "negationist" or "genocide denier" by the Kagame regime, and accused of carrying in my blood the nonsensical and nonexistent Hutu genocidal ideology. Today, I have decided to write my story to show that Hutu are not born with criminal minds, and to protest against the current regime in Kigali that stigmatizes Hutu children born after the 1994 Genocide as bearers of the sins of genocide. Some Hutu, and some Tutsi, did indeed participate in the 1994 Tutsi genocide in Rwanda, and the 1996 Hutu genocide in the Congo, but the guilt for these crimes against peace and humanity must not be laid on those who neither planned nor perpetrated them. Criminalizing an entire ethnic group is racist and completely negates the proclaimed values of Kagame's "People's Reconciliation."

Growing Up in Rwanda

I was born in Rwanda, grew up there and lived my young adult life there until I was forced into exile in July of 1994, when the Tutsi RPF defeated the Hutu army and government. Had I not escaped, I would have been killed for being born Hutu. My grandmother, 80 years old, was hiding in a house with other family members, neighbours and friends when they were attacked by the RPF soldiers. My grandmother naively attempted to appease the killers and they immediately beheaded her. The soldiers then burned the house down around the

others, and all perished. Four days later, a close relative arrived at the scene and found my grandmother's head lying beside her body, and all the others charred beyond recognition.

This massacre happened in 1997. My grandmother and the others had elected to stay in Rwanda and not to flee into exile as I and so many others had done. I had asked many of my contacts in Rwanda about her death over the years, but even family members would always say they knew nothing about it, for fear of reprisal. It was only when some of them managed to leave Rwanda 15 years later, that I learned what Colonel and Brigadier General Kayumba Nyamwasa's troops had done to her. Nyamwasa, known to Ruhengeri Hutu as 'the Butcher,' today is a refugee himself, carrying in his stomach a bullet that he claims was shot by Paul Kagame's hired assassins in South Africa.

Countless Rwandans in Ruhengeri province, a great host of neighbours, colleagues, classmates, friends, cousins, brothers, sisters, uncles, aunts, nieces, nephews, moms, dads, and grandparents were killed by Tutsi RPF soldiers under Kagame's command. I am in a position to know that not one of these Hutu civilians had been involved in the 1994 Tutsi genocide, or any action against Tutsi, because there had been virtually no Tutsi in Ruhengeri where they were living in 1994. They were targeted and killed simply for the sin of being Hutu.

Another shocking murder was that of my best childhood friend, Côme. We had been friends from toddlerhood, until, as young men, we were separated by the exodus of 1994. Côme ended up in a Congolese refugee camp in 1994, remaining there until the camps were destroyed in the 1996 Hutu genocide in Congo, in which approximately half a million Hutu were wiped out. This ultimately forced him to risk returning to Rwanda.

In 1998, I learned that he had been shot dead on the street in Nyamagumba area in Ruhengeri in broad daylight, by a well-known RPF officer who wanted Côme's wife. In cold blood, he murdered Côme and took his wife. I couldn't understand why he didn't just take Côme's wife and let him live. I still grieve for my childhood friend, a sweet and gentle guy who couldn't even bring himself to kill a chicken in the hen house.

Côme is in white and I am in black during his wedding 1992

So many of my childhood memories include my friend Côme. In 1972, my parents registered me at the kindergarten in the Pentecostal Church close to our neighbourhood. Côme, my buddy, was attending a second-grade school in a combined kindergarten and I first grade class. The following September, we waited together on the rickety benches outside my school to register for entry into Grade 1 and Grade 3 respectively. My parents were fervent Catholics, but they let me follow my friend, on the condition that I never tell our local priest that I was studying with the Pentecostals. Côme and I knew each other and were related, but our strong bond of friendship really started there, and we would be together as best buddies until 1994. Côme was three years older than me, but we were almost the same height, and he entered Grade 3 as I started Grade 1.

Côme and I stayed at the Pentecostal school for less than half a year before transferring to the modern Catholic elementary school at Nyange. My brother and sister were going to Gasiza, an old school where the roof leaked and they had to come home whenever it rained heavily; Côme and I were proud to be at our new public school with its new benches and free study materials, and its well-trained young teachers who enthusiastically organized soccer, volleyball, boy scouts, girl guides, and drama.

Côme's father, Boniface, and my dad, Gaëtan, both had strong ties with the family of Munyambarara and his sons Gatsinduka and Bitaba, the only Tutsi family that lived anywhere near our neighbourhood. Our families both had cows, and our fathers both decided to have Munyambarara's family look after them. Their plan was that, as Munyambarara was a Tutsi who raised cattle in the traditional ways of his people, they would give him some farm land in exchange for his services, and put a bunch of many cows in his care.

Côme and I were sent to look after the herd during the summer holidays until grade five. We both enjoyed relieving

the two Tutsi sons, Gatsinduka and Bitaba, so that they could go
and spend time with their young wives. Côme loved to drink
the fresh milk that we pulled from the cows' udders, and I loved
buttermilk, which I am still very fond of today.

In 1973, Hutu President Kayibanda's regime was driving
Tutsi out of Rwanda in response to the Hutu genocide in
Burundi that had killed around 200,000 Hutu there. Côme's
father and my dad, along with other Hutu friends, stopped a
Hutu mob who wanted to burn Munyambarara's house and his
sons' houses in the same compound and send them into exile in
the Congo. They hid the family and protected their houses from
being looted and burned. Munyambarara was able to return to
his home after a few days, unlike others who were forced to
take refuge in the Congo.

Around the same time, I witnessed my father hiding
another Tutsi neighbour, Samuel Semucyo, on our pyrethrum
plantation ten miles from our home. Samuel was forced to spend
six months out of the country, and then my father helped him
resettle in his house, which had unfortunately been completely
looted by his Hutu neighbours.

In August of 1973, when Habyarimana, a northern Hutu,
deposed civilian Hutu President Kayibanda, who was from the
south, he took steps to restore order and peace after the chaos
of the previous two years. Tutsi were invited to come back to
their studies, in elementary school, high school, and university.
They were urged to take up their professions, return to their
homes, and go back to their properties and businesses. My
father helped Samuel to reconcile with those who had looted
his home, and asked the looters to make restoration of the stolen
goods and damaged buildings. Though, I was a young boy, I
was not too young to understand that our Tutsi neighbours had
been treated very unfairly and harshly by Hutu government in
general. I also know that in today 's Rwanda, Kagame is treating

Hutu unfairly and harshly in the same manner his predecessors oppressed the Tutsi.

I do not agree that Kagame's regime has the right to take revenge for what previous Hutu regimes did to Tutsi citizens. Leaders must protect their citizens regardless of ethnicity or political allegiance; it's as simple as that. That is how we can move forward. The Rwandan government under Kagame is a long way from understanding, and even further from adopting, this straightforward principle.

Tragically, when the RPF invaded Ruhengeri province in 1991, Samuel was killed. Whoever killed him, Tutsi or Hutu, there is no excuse. I remember how as a child I was loved by the Tutsi in my father's circle, and how I and other neighbours loved them and respected them as if they were our own family members. They ate and stayed at my home, just as I ate and stayed at theirs. That they were Tutsi and we were Hutu was never an issue. This is the paradox of Rwanda: in the midst of ethnic and racial tensions, Hutu and Tutsi can love each other as brothers and friends.

I never heard of any Tutsi being killed in our community. I did grow up knowing that President Habyarimana's government did protect them. However, in early years, Hutu burned their houses and looted their properties, but the Tutsi in my surrounding area stayed. Things turned out a bit differently for me. I would have no choice but to leave Rwanda altogether and I was very fortunate not to have been killed.

I feel empathy for the Tutsi's pain, and I know Kagame experienced the same pain in his years of exile in Uganda. But neither Kayibanda nor Habyarimana followed the Tutsi into exile to kill them, as Kagame has done with the Hutu. His agents have followed us wherever we might go, be it Congo or Canada.

I have only had citizenship in Canada since becoming stateless in Togo in 1996 under the 1951 Geneva Convention. According to Rwandan law, should I wish to recover my Rwandan citizenship, I need only to write a letter requesting reinstatement of Citizenship to the Minister of Justice and I will get it automatically; much good it may do me. As I see it now, it's better to live in a country—even if it's not my own from birth--than to return to a jungle.

During all the past conflicts that have set the Hutu and the Tutsi against each other, my family's position has always been clear; one of compassionate support for the Tutsi population whenever they were victimized. In 1964, a date that was burned in my parents' memory, Tutsi insurgents from Burundi invaded the Gikongoro in southern Rwanda. Later that year, they again entered Rwanda through our district of Kinigi and through Virunga Park, close to my parents' home. Kayibanda's soldiers responded by persecuting Tutsi non-combatants in our region. My father told us how in 1964, he sheltered a Tutsi woman, Nyirabukuzungu. She came and hid in a hut behind the house, and our neighbours did not dare enter our property to harm her or remove her. Over the next day or so, my father escorted her and her children through Virunga National Park to Bufumbira in Uganda where her husband had already fled. He put them under the protection of his uncle, who had immigrated to Uganda in the 1920's to avoid enslavement by the Tutsi in Ruhengeri. To help the family, my father later bought the land they had been forced to abandon, and brought the money to them in Uganda.

My father would tell this story to add a realistic perspective to the historical topics we studied at school, such as the 1959 Hutu Revolution, and the reasons why some Tutsi had left Rwanda. On Independence Day and referendum days, our neighbours would prompt my father to retell the story about

Nyirabukuzungu, and we children listened and remembered. The moral was that we must be kind and offer protection to people in danger. It was a powerful lesson for us, and one that stayed with us through our lives.

There is an unfortunate postscript to this tale, which is that when a young grandson of Nyirabukuzungu's family came back to Rwanda after the 1994 RPF victory, he was able to seize the land that my father had bought from his grandfather, without any payment whatsoever. This was possible because the Tutsi had now become first-class citizens, and the Hutu had become second-class citizens. I heard this story after my father's death in 2003, and it wounded me deeply. This, I said to myself, is the new Rwanda by and for the Tutsi and the RPF.

Rwandans' "Wisdom": the story of the Blood Pact

Ordinary Rwandans have often shown themselves to be very wise compared to their respective Hutu and Tutsi political leaders. Understanding that hatred had been their leaders' tool to divide them from time immemorial, ordinary Hutu and Tutsi, and the tiny minority of Twa, developed a blood pact, a formal ceremony of blood-brotherhood, known as *"Kunywana"* in Kinyarwanda language. This consisted in "sipping each other's blood" with the intention of becoming blood brothers. Those who drunk but sip each other's blood had strong obligations. This Rwandan tradition and custom entails each making a tiny incision on the umbilical knot of the other, and then sipping a little bit of the other's blood. After this ritual is completed, the participants and their families are understood to be in a close and permanent relationship. People believe that, should a member of one family do anything to betray this alliance, that person would die or suffer under a curse as a consequence.

Photo taken during Côme's wedding but similar to
what is done during the blood pact -Côme's Best
Man and I drinking the local beer" IKIGAGE".

The tradition of the blood pact has a place in my own
ancestry, providing an example of the enduring bonds that often
existed between Hutu and Tutsi. When I was about 6 years old,
I was told by one of my uncles that years before, my mother's
father, Bukoko, had made a blood pact with the Tutsi Kabuguri.
This meant I now had two maternal grandfathers. I asked my
grandmother if that were true, and she told me that it was, and
that I must commit in my mind and heart never to do harm to
any Kabuguri's family member under any circumstances. At
this time my grandmother was a widow; her sons were grown
up and established in their own work and families, and I would
therefore volunteer to help Kabuguri's sons who were looking
after my grandmother's herd. I treated them just as if they were
my biological uncles. Kabuguri in turn would attend any family
ceremony of ours, and was very kind to me and others; I treated
and respected him just as if he were my blood grandfather,

and my uncles, who were established in careers in the legal professions and as civil servants, treated him just the same way.

Thus in my own life, there had never been any animosity between Hutu and Tutsi, and I knew there was nothing inherent in either ethnicity that would make them behave in a criminal way. Hatred can be inculcated in children by their families, just as it has been nurtured by politicians in Rwanda as an instrument to divide, rule, and ultimately to ruin my country. In contrast, my family instilled in me and my siblings good moral values: altruism, critical thinking, and protection of others. I was taught that instigating violence was a sign of great weakness, while self-defense was a virtue. My grandmother, who carefully taught me to love and never to harm any Tutsi, was a victim of skillfully-wielded political hatred and died dismembered, beheaded by RPF soldiers. Rwanda is a land of great contrasts: while some would show compassion, others would perpetrate hate.

When I reflect on the moral values that were instilled in me at an early age, I find they are a very solid foundation for an education in human rights. They were reinforced by my academic studies, by my life experience in the turbulent world, and the good people I have met across the planet. The highest lesson that I have learned was that one must never respond to anger with anger, and that violence is never the solution for any problem. In my view, Rwandan President Paul Kagame is an angry man who has never learned these lessons and openly mocks such notions; I do not see how he can bring solutions to Rwanda's historical problems. In fact, many would see him as an agent of destruction.

The beliefs my family and community instilled in me did not leave me the option of standing idly by during the April 1994 bloodbath at Mudende University. Facing spurious allegations of war crimes, crimes again the peace, crimes against humanity, and the crime of genocide hurt me profoundly, angered my

family enormously, frightened my relatives relentlessly, and shocked my friends and acquaintances even more than it had surprised me, since I had been far less sheltered in life than they, in many ways.

Time is often the best cure, and I had always been optimistic that the fabricated charges would dissipate, blow away like smoke in a kitchen, and perhaps come back to choke those who had devised them. They left me scarred, traumatized and grieving, but this experience also made me stronger and more forgiving, even to those who harmed me. Most importantly, I came out of this ordeal with hope and optimism that future generations would one day live in a better Rwanda, free from corrupt political leadership.

It's interesting to see how the winds are changing as more information comes to light about what really happened in the years during and following the Rwanda genocide. Tutsi RPF Major, and Ambassador to the USA, Dr. Théogene Rudasingwa, is just one of the many Tutsi and Hutu who endorsed and worked with the RPF Liberation Movement. Now, after 20 years, he has appeared in Western media, renouncing his past allegiance and claiming that it was through naiveté that he had allowed himself to be recruited to Kagame's Killing Machine. Is this remorse genuine? Or is it motivated by the fear of new information coming to life that will condemn him and his colleagues? While I agree that it takes a brave man to admit his wrongdoing and put himself back on a righteous path, it is important that remorse is genuine, and is accompanied by a sincere desire to amend for wrongdoing. It is also important that true justice is administered fairly for those who were actually responsible for Rwanda's war crimes. This is true not just in my homeland, but for the international community as well. The vast majority of Rwandans fervently hope that the current leadership of Paul Kagame will end soon and peacefully.

Chapter 13

FALSELY ACCUSED OF PLANNING THE 1994 GENOCIDE

L ET ME RESTATE HERE that I, like so many others, was falsely accused of being among the Hutu who planned and perpetrated the Tutsi genocide. My actual role in the protection of all students during the Mudende University massacres was irrelevant to my accusers, as was the inconvenient reality that, when the charges against the 64 Hutu accused before the International Criminal Tribunal for Rwanda (ICTR) of planning and perpetrating the 1994 Tutsi genocide were finally investigated, the Court could find no evidence whatsoever to support the claim of a crime of genocide.[39]

[39] ICTR did not find *mens rea*, i.e. intent, of the crime of genocide for any of the 56 Rwandan Hutu defendants prosecuted at Arusha. There simply was no evidence that anyone had planned it. There were plenty of crimes against humanity. There were plenty of individuals and groups exhorting others to kill Tutsi, in a climate of fear and revenge. But there was no discoverable intent to commit genocide, nor a plan to do so, in 1994.

However, it is not in the judicial courts where accusations of genocide have been hurled to see where they might stick, it is in the court of public opinion, and it is in the media. It is in the diabolically clever misinformation campaigns that have made the RPF's myth-making into the accepted narrative of what happened in Rwanda. The consequences of that propaganda campaign have been dire for many who were falsely accused. And even though I was eventually cleared of all charges like many others, the accusations exacted a heavy toll. These allegations were ludicrous and carried no weight, yet the stigma attached to being accused and investigated still haunts me. I am concerned for all those who have been smeared by, and continue to endure, the same groundless allegations. The current Rwandan government continues to emit an unabated river of false allegations against Rwandans, both inside the country and in the Diaspora, if they dare to criticize the RPF

I have heard Rwandan lawyers and lay people arguing endlessly over a definition of intent, but their attempts to explain it have been wholly inadequate, except those of Professor Charles Kambanda, who is very learned in applications of Common Law.

So there is and should be no indictable crime of genocide for the 1994 Tutsi Rwandan Genocide. Even the much more carefully planned RPF 1996 Genocide against Rwandan Hutu in Congo is probably not legally prosecutable as such, even if anyone internationally had the will to do so. Nonetheless, in my view, each of these two crimes qualifies as genocide. For clarity I have differentiated them as **Spontaneous** Genocide (against the Tutsi, in Rwanda, in 1994) and **Pre-emptive** Genocide (against the Hutu, in Congo, in 1996.) The former arose out of deep fear of, and hatred for, the RPF invaders who had put themselves within striking distance of reestablishing Tutsi hegemony in Rwanda, and was triggered by President Habyarimana's assassination. The latter was a carefully planned campaign of mass killing of Hutu who had fled before the RPF invasion, and who were defined by the RPF as a genocidal criminal militia.

regime, or fail to cooperate with its programs and plans in any way.

I urge all those in the Diaspora who have been falsely accused, to come forward and talk about their victimization. It is important to shed light on this pernicious form of persecution and intimidation. I understand very well how the threat of danger and the sting of false allegations can make it difficult for innocent people to share their stories. But if we endure these false charges in silence, power will always remain in the hands of the accusers.

Those of us living outside Rwanda have a particular duty to speak out. For the most part, we enjoy far greater protection than those still living under Kagame's regime. Since we have this open arena to speak out about the truth, we have a responsibility to be brave and expose the truth. If we remain silent, we betray our fellow Rwandans who have been, and continue to be, unjustly accused and unlawfully convicted in Rwanda. The majority are innocent, illiterate, and poor villagers, who need the voice of those of us who are educated and privileged and who enjoy personal security, a high quality of life and freedom of expression in Western countries.

Regardless of any physical or moral torture we undergo, we must be stoic and courageous. It has been common in Rwanda for some of us to turn on our brothers and sisters in exchange for advancement or to escape personal suffering. It is not rare for people to falsely accuse their neighbours and friends of fabricated crimes. Many have abandoned their moral commitment to telling the truth. If Rwanda wants to heal, people must get beyond this. There are many Hutu and Tutsi who have accused, harmed, and offended against their fellow countrymen. These men and women need to bear the consequences of their actions and genuinely ask for forgiveness from those they have wronged. On the other hand, many of

us did nothing wrong, never turned on our brothers or sisters and had no role in the genocide. These men and women should not be coerced into apologizing and forced into accepting this burden, as the RPF is demanding of all Hutu in the program of *Ndi Umunyarwanda*.

Please don't misunderstand me; it is clear to me that Rwandans have engaged in two genocides: the 1994 Tutsi genocide in Rwanda and the 1996 Rwandan Hutu genocide in the Congo, DRC. I know not a single Rwandan who would argue against this statement. In the carnage of both 1994 and 1996, Rwandan Hutu and Tutsi killed one another based on ethnic and perceived racial differences. Some experts have tentatively characterized these 1994 and 1996 barbarities as the *Tutsi Spontaneous Genocide* and the *Hutu Defensive Genocide* respectively and I agree with them. However, one chooses to identify these two massive bloodlettings, they are clearly and unequivocally both genocides.

I am in no way a 'negationist' or 'Tutsi genocide denier,' though if I were to set foot in Rwanda I would immediately be jailed and perhaps executed on such charges, just for what I have written in this book. My focus, rather, is on the ongoing use of groundless criminal charges in a completely captive legal system, and on the use of terror to suppress people and exert power over them. Many inside Rwanda have been crushed by constant assaults by the legal and political apparatus from which they may never escape. Only those of us on the outside are in any position to expose these abuses and speak against them.

Rwandans, both Hutu and Tutsi, know exactly what they themselves have done in the way of genocide. They don't need international actors to explain to them what happened. The agencies and legal scholars investigating this history, including the ICTR, only possess hearsay and the stories crafted by the RPF. They have no admissible evidence. The real and healing

Court or Tribunal, what I call a 'Criminal Forum for Rwandans,' belongs only to Rwandans themselves. UN Secretary General Kofi Annan put it very well when he told Rwandan politicians and lawmakers in the legislature in Kigali in May, 1998, *"You and only you can put an end to violence. You and only you can find the spirit and greatness of heart to embrace your neighbours once again."*[40]

Instead of listening to Annan's advice, the Rwandan Foreign Affairs Minister, the zealous Hutu Anastase Gasana (today in exile in the USA), insulted Annan. The President, Hutu Pasteur Bizimungu, (today serving 10 years' probation after 5 years in prison) and Vice-President Paul Kagame, (today the President of a so-called liberated Rwanda) reacted to the speech by boycotting Annan's planned dinner reception.[41] Gasana, Bizimungu, and Kagame went on to force the Speaker of the House of Commons, Joseph Sebarenzi, to flee into exile in the USA for candidly agreeing with Annan's advice. The ground was not very fertile for honesty and real reconciliation within Rwanda in 1998. And it is not any better today, almost two decades later.

And so the burden must fall on those of us outside Rwanda to expose the hideous hold that Kagame and the RFP have on Rwandan society, the crimes they have committed and continue to commit, and the excessive influence that they and their clever myth-making have had over international bodies and world media. It is not a hopeless task. We are seeing courageous academics like Robin Philpott, and journalists like Jane Corbin of the BBC, risking opprobrium as 'genocide deniers' as they bring forward new perspectives and a much more complex story

[40] Text of Secretary-General Kofi Annan's address to the Parliament of Rwanda, in Kigali on 7 May 1998. UN Press Release SG/SM/6552 AFR/56

[41] *In Sebarenzi, Joseph. God Sleeps in Rwanda: A Journey of Transformation. Atria, 2009.*

than what the world has been fed. I ask all Rwandans to take heart from this, and to come out of the shadows. In this way, and in time, we will build a new Rwanda, the better Rwanda that our good and loving peoples deserve.

Epilogue:
THE PRIMACY OF ETHNICITY: FERTILE GROUND FOR CRIMINAL MINDS

I N ORDER TO UNDERSTAND the genocides, one must understand how deep-rooted the matter of ethnicity is for Rwandan people. Being Hutu or Tutsi is much more than a cultural heritage. More than any other human attribute, ethnicity is what counts in life; it is pivotal to personal identity. Ironically, Hutu and Tutsi people are in reality almost indistinguishable, sharing the same culture, language, territory, faith, and occupations. As I described earlier, deep blood bonds can exist between Hutu and Tutsi families. And yet, in Rwandan culture, ethnicity is nearly impossible to get beyond. Even where a host of other factors determine an outcome, one's ethnicity will always be the authority to fall back on to explain what has gone wrong. Should an inter-ethnic marriage fail, it is because he was Hutu and she was Tutsi, or the other way around. No other explanation is required. Alcoholism, abuse, infidelity, conflicts over parenting, every kind of personal incompatibility or other marriage problem: whatever the real reasons might be, there is no need to look for them. The explanation that suffices is that the marriage failed because of the partner's ethnicity. And ethnicity is so pervasively seen as the root of conflict, and the

expectation is so strong that it will be so, that when conflicts arise between good and close friends of different ethnicity, they can become enemies in an instant. The separation between Hutu and Tutsi is the bedrock that underlies all social reality.

My experience growing up in beautiful Rwanda was that discrimination based on race was apparent and normal. Even the schools were not free of bias. Some teachers would discriminate against a student not of their own ethnic group, even though that child had earned the same grade as his classmate. Conversely, in those cases where the teacher didn't discriminate on an ethnic basis, there was perceived discrimination; if a Hutu or Tutsi student failed, he would blame it on the teacher's being Tutsi or Hutu. I remember a Tutsi graduate student from Kibungo Province, who failed the first year of his Masters at the National University. It was not hard to deduce that this had been due to his weak performance, but he persistently blamed his Hutu Math professor from Ruhengeri Province for his failure. Family and friends generally would not question these sorts of claims, and would readily accept them as true. And each instance of perceived discrimination powerfully reinforces people's assumptions that ethnic bias is everywhere.

Differences between the two groups often surfaced in church. Disagreements unrelated to ethnic identify could quickly divide a church into Hutu and Tutsi camps. Trivial matters would escalate and mutual discrimination would take root. Animosity would then permeate everything; the selection of students for some seminary schools would depend on the ethnicity of the priests selecting the candidates. The seminary at Nyundo, representing Gisenyi, Kibuye, and Cyangugu provinces, was dominated by Tutsi priests from who invited predominantly Tutsi to study for the priesthood while Rwesero seminary was dominated by Hutu priests from Byumba and Ruhengeri who encouraged mainly Hutu candidates.

And so there was conflict, there was animosity, and there was suspicion, but generally speaking it took an extraordinary event to provoke serious violence. During the entire period of Habyarimana's presidency, from 1973 until 1990, I cannot recall any incident where a Hutu or Tutsi was killed for his/her ethnicity. But all the simmering discrimination, and all the petty and not-so-petty grievances between Hutu and Tutsi neighbours and colleagues provided fertile ground on which the seeds of fear began to fall when the RPF invaded in 1990, seeds which then blossomed into uncontainable rage with the assassinations of April 1994. What had been sporadic conflict then ignited into *Spontaneous Genocide*. Mutual hatred and mutual destruction blew away all the uneasy truces and accommodations of every local community's earlier years. There would be no going back.

In this new paradigm, even atrocious acts against a person of the other group were considered acceptable. If a Hutu killed a Tutsi, it was assumed among the Hutu community that the act was justified. During this first genocide, people would say, "Everything in the entire world belongs to the Hutu." On the Tutsi side, large scale mass killings at the hands of the RPF, under a military operation called Punguza Watu which means 'kill Hutu to reduce them,' were approved of by many Tutsi people.[42]

On hearing that Tutsi had been murdered, some Hutu would say, "they provoked their own killing." Even Hutu sympathetic to individual Tutsi victims were at serious risk of

[42] One can read more about the culture of ethnic violence in credible stories such as that of Sociologue Madame Claudine Vidal, Maurice Niwese in his book *Le peuple rwandais, un pied dans la tombe, récit d'un réfugié étudiant*, Collection Mémoire Africaines, Edition L'harmattan, 2001, pp 159 -162, and the DRC: Mapping human rights violations 1993-2003 by the United Nations Human Rights.

falling into demonizing stereotypes about Tutsi. There were not many people who occupied the moderate middle of the ethnocentric political spectrum, and the few that did were generally of mixed Hutu and Tutsi descent. And so, by 1994, the climate was ripe to excuse horrendous violence against the group that was not one's own ethnicity.

Over twenty years after the genocides of 1994 and 1996, both sides still do not have fundamental respect for each other. On a superficial level they seem to be living in harmony, getting along and working together in peace. But beneath the surface the same prejudices and habits of thinking that led to the slaughter of a million adults and children still persist. And though the current government portrays itself as making great strides in building new ethnic relations, in fact they appear to be institutionalizing ethnic separation and hatred. They said they would be bringing about a new peaceful coexistence. Hutu and Tutsi were instructed to go back and reconcile their differences in order to establish a basis for peace. However, this doctrine of peace is more propaganda than anything else, and is in reality very weak. The real and deep-seated problems between the two ethnic groups have not been addressed, and are not recognized. A Band-Aid has been put on top of the massive wound in order to stop the bleeding, but all is festering underneath. Tutsi and Hutu have no respect or care for each other. Growing up in Rwanda these days, you learn to fight for your own interests, watch out for your own family and put yourself first. There is only a smattering of education on basic human rights. Human life is not valued as it should be, and the ethnic divide makes this worse. Of course, the killings needed to stop and some manner of reconciliation was essential. However, in the haste to restore peace in Rwanda, no one had the courage or the wisdom to identify and address the underlying issues.

Reconciliation has been superficial at best, and, as terrifying as the thought may be, over time the cycle of violence will likely recur. There is no joint culture or social order holding the Tutsi and Hutu together, and President Kagame seems to have no interest in building one. When things get rough, citizens will dive back into their own ethnic group, and ignore the needs of the other.

Rwandan politics lacks a foundation of principles or moral values. It is a succession of cults of personality. Each new leader dictates anew the culture and social structures, and this exercise is invariably superficial and at the whim of the new leader. There is nothing solid for the people to hold onto. The nation is shaped based on the leader's views, theories and interests. None of the critical components of civil society is rooted in anything substantial. When a new leader comes into power, he turns over the soil and spreads the seeds of his own views. Rwanda will not begin to address its fundamental needs until it builds a republic with the rule of law and democratic institutions. Such a project is nowhere on the horizon.

A scan through the history of Rwandan administrations since independence reveals a pattern of autocratic rule advancing the interests of the president's ethnic group. The first president, Grégoire Kayibanda, 1960-1973, was a Hutu. His electoral platform called for social revolution. Almost all Hutu and a large number of moderate Tutsi or commoners supported his plan to rid Rwanda of the Tutsi monarchy. Kayibanda ran on a platform of national unity for ordinary Rwandans of all ethnicities, but once in power, he dropped this façade; during his presidency he removed many capable Tutsi from positions of influence in the bureaucracy, downgraded the roles of Tutsi in government and pushed them out entirely when he sensed he could get away with it. And every time the expelled Tutsi elite invaded the

country from Uganda and Burundi,[43] there were mass killings of Tutsi in Rwanda.

On July 5th, 1973, Major General Juvénal Habyarimana seized power from Kayibanda in a coup d'état. There were two main reasons among others for this coup: first, there was chaos in the country after the expulsion of competent and qualified Tutsi, Hutu, and expatriates from schools, jobs, business, and cooperation; and second, the increased funding for schools and increased employment that Kayibanda had promised were very slow to materialize as well as wanting a political third term. Moreover, Kayibanda had not confined his discrimination to the Tutsi, and had marginalized Northern Hutu as well, expelling them from top political positions in his government. The first president was reducing both Northern Hutu and all Tutsi to the status of second-class citizens, in favour of Southern Hutu.

There was significant animosity and rivalry between Northern Hutu and Southern Hutu. President Habyarimana promised to repair this divide and create national unity. However, he performed no better than Kayibanda in establishing equity for the ethnic and regional groups. He essentially flipped the balance of regional power that had developed between 1973 and 1990, marginalized the Southern Hutu in their turn, and firmly established Northern Hutu in the highest positions of government. On October 4th, 1990, in retaliation for the RPF invasion, Habyarimana jailed around 8,000 Tutsi and Southern Hutu. He believed these people were associating and collaborating with the RPF insurgents.

The current president, Paul Kagame, has been in power from the genocide of 1994 until today. His plan of action

[43] Most notably in 1963 and 1967. There were in total 7 Tutsi invasions during Kayibanda's administration.

included humiliating, silencing and purging from all institutions influential Hutu who had supported his party, the RPF, during their struggle to seize power in Rwanda. Many were killed, among them Minister of the Interior Seth Sendashonga, Colonel Théoneste Lizinde, and President Pasteur Bizimungu. Many others were forced into exile. At the same time, Kagame marked for death or exile those in his own inner circle of Tutsi who believed that, after the 1994 Tutsi genocide and the 1996 Hutu genocide in the Congo, it was time for a genuine reconciliation, and who wanted to stop the ongoing killings in Congo.

Is there anything in all this to make us think that Rwandans can put a stop to the constant cycle of power reversals and revenge, alternating between the Hutu and the Tutsi? This country does not have a single well-defined identity, but rather two separate identities, Tutsi and Hutu. National identity is forever subordinate to ethnic power, and the most powerful interests are concerned only with this kind of power and who shall wield it. The country remains in a cycle of non-stop violence; violence simmers just under the surface at all times. Children are conceived and develop under these psychological and social conditions. They are raised in a climate of fear, violence, mutual suspicion and bitterness. They will be the predictable product of the circumstances in which they are being raised. Violence will continue to erupt because it is what they know; it is the backdrop of political and social action. Many Rwandans like me have experienced peaceful decades where ethnicity, in some places, did not destroy community or take the dominant role; but we are not lulled into complacence. The history of Rwanda does not contain a peaceful and harmonious era. People of one ethnicity build the economy and institutions, and the next ruler tears them down in the interests of his own ethnic group. There are individuals imbued with moral

consciousness, but there is no collective civil morality, and there will be no golden era for Rwanda until that has been achieved.

In Rwanda today, you are offered two roles: the oppressor or the oppressed. If neither of these is a role you care to take, you have the option of living in exile with a lifetime of regrets. Many Rwandans are living in the Diaspora, angry and resentful, and hoping to go home someday. They are living in countries with freedom of expression, but they themselves feel they are denied that right, because, even at great distance from Rwanda, they will become political targets for Kagame's agents should they express what they think and know.

And so be it. There is a great wealth of ill-inspired misinformation that has been written about Rwanda, with the result that almost nobody in the West knows what happened there at all. This includes many of those who have styled themselves as experts and won international acclaim, standing on the shoulders of others as ill-informed as they are. The demonization of all Hutu, and the whitewashing of all Tutsi, is a scam for the ages. It is time that people in the Rwandan Diaspora, Hutu and Tutsi alike, start telling what they know, sharing their real experiences that stand in stark contrast to what the Rwandan government and their allies in the West have foisted on a gullible world.

Acronyms

UPC:	Uganda People Congress
DRC:	Democratic Republic of Congo
UNHCR:	United Nation High Commission for Refugee
DMI:	Directory Military Intelligence
NRA:	National Resistance Army
CIA:	Central Intelligence of America
CIS:	Canadian Intelligence System
RPF:	Rwandese Patriotic Front
FAR:	Rwandan Army Forces
MRND:	National Revolutionary Movement for Development Party
MDR:	Republican Democratic Movement Party
PL:	Liberal Party
PSD:	Social Democratic Party
IBYITSO:	Traitor
IKINANAI:	President Habyarimana nicknamed himself Ikinani = Invincible
OAU:	Organization of African Unity
CND:	National Council for Development (Rwandan Parliament)
UNAMIR:	United Nations Assistance Mission for Rwanda
RCMP:	Royal Canadian Mounted Police
UAACM:	Adventist University of Central Africa Mudende
ID:	Identification
PhD:	Doctor of Philosophy
MA:	Masters of Arts
BA:	Bachelors of Arts
BBC:	British Broadcasting Corporation

ICTR:	International Criminal Tribunal for Rwanda
USA:	United Stated of Amercia
UK:	United Kingdom
RTLM:	Radio Television des Mille Collines
CEO:	Chief Executive Officer
PTSD:	Post Traumatic Stress Disorder
INYENZI:	Ingangurarugo Yimeje Kuba Ingenzi

Bibliography

Akodjenou, A. (1995). *Lessons Learned From The Rwanda Emergency*. A workshop held at the Chateaud des Penthes, Geneva, May 1995, pp. 15-17.

Berry, J., & Berry, C., (Eds.) (1999). *Genocide in Rwanda: A collective memory*. Washington, D.C: Howard University Press.

Conrad, R. (1984). *Children of God's fire: A documentary history of black slavery in Brazil*. Princeton, NJ: Princeton University Press.

Cruvellier, T., et al. (2004). *Augustin Cyiza: Un homme libre au Rwanda*. Edition Karthala. Retrieved from www. karthala.com

Dallaire, R., & Beardsley, B. (2003). *Shake hands with the devil: The failure of humanity in Rwanda*. Toronto: Random House Canada.

Gasana, J. (2002). *Rwanda: du parti-État à l'État-garnison*. Paris: L'Harmattan.

Gbardy, J. (2014). *Painful Journey: A story of escape and survival.* Victoria, Canada: FriesenPress.

Gibbs, N. (May 16, 1994). Why? The Killing Fields of Rwanda. *Time,* retrieved from http://content.time.com/time/magazine/article/0,9171,980750,00.html#ixzz2rUsszqKi. Johnson, C. (1998). *Africans in America.* Orlando, FL: WGBH Educational Foundation.

Jones, B. (2001). *Peacemaking in Rwanda: The dynamics of failure.* Boulder, CO: Lynne Rienner Publishers

Martin, G. (2010). *Understanding Terrorism: Challenges, perspectives, and issues.* London: Sage Publications.

Munyabagisha, F. (2012). *Rwanda.Pourquoi nos fossoyeurs sont-ils vos heros? Les faces caches des tragedies.* Montreal, Canada: Edition Lambda.

Mushikiwabo, L, & Kramer, J. (2006). *Rwanda means the universe: A native's memoir of blood and bloodlines.* New York, NY: St. Martin's Press.

Ndacyayisenga, P-C., (2012). *Voyage a travers la mort: Le temoignage d'un exile Hutu du Rwanda.* Montreal: Groupe Marie Litterature.

Ndagijimana, JMV. (2009). *Paul Kagame a sacrifie les Tutsi.* Paris: La Pagaie.

Ndagijimana, JMV. (April 9, 2013). Paul Kagame sacrificed the Tutsi. In *TFR - Jean-Marie Ndagijimana's Blog.* The Franco-Rwandan Tribune. Retrieved from https://translate.google.ca/translate?hl=en&sl=fr&u=http://www.france-rwanda.

info/article-paul-kagame-a-sacrifie-les-tutsi-116936349.
html&prev=search

Ntilikina, F. (2014). *Rwanda, Les Forces Armées: Répondre à l'histoire*. Bruxelles: Editions Scribe.

Paternostre de la Mairieu, B. (1994). *Toute ma vie pour vous, mes frères! Vie de Grégoire* Kayibanda, *premier Président du Rwanda*. Paris: Pierre Téqui.

Pean, P. (2005). *Noires fureurs, blancs menteurs: Rwanda 1990-1994*. Paris: Fayard, Mille et une nuits, Libraire Artheme.

Pilger, J. (2004). *Conspiracy to murder: The Rwandan Genocide*. London & New York: Verso, New Left Books.

Sebarenzi, J. (2015). *Democracy and long lasting Presidents in Africa*. London, UK: British Broadcasting Corporation. Retrieved from http://www.bbc.co.uk/gahuza/umviriza_kandi/2014/08/000000_imvo_nimvano

Soro, G. (2005). *Pourquoi je suis devenu un rebelle: La cote d'Ivoire au bord du gouffre*. Paris: Hachette Litterature.

Thompson, A. (2007). *The media and the Rwanda genocide*. London, UK: Pluto Press.

Tremblay, R. (2007). *Understanding Human Rights: Origins, currents, and critique*. Toronto: Library and Archives Canada.

UPC And Banyarwanda -1982: Facts and Figures and The Chasing of the Banyarwanda. (n.d.) Retrieved from https://semuwemba.files.wordpress.com/2010/03/upcandbanyarwanda.pdf

Viret, E. (March 2010). *Habyarimana, Juvénal.* Online Encyclopedia of Mass Violence. Retrieved 19 December 2014 from http://www.massviolence.org/Habyarimana-Juvenal, ISSN 1961-9898

Williams, F., & McShane, M. (2010). *Criminological Theory,* 5th ed. New Jersey: Pearson.

What happened in Rwanda?

APRIL 6, 1994. THAT date would be seared forever in the memory of Jean Jacques Bosco, a university student in Rwanda at the beginning of the genocide.

In just a few days, he and his fellow students saw the end of the world they knew. Friends turned against friends. Innocent students were massacred. Desperate to save all he could, Bosco led a group of students in a dangerous escape through a unfriendly civil war zone, risking everything to find safety and freedom.

No One Else Knows What Really Happened in Rwanda is the searing account from one who grew up there, who intimately knew the political tensions that birthed the civil war and the ensuing genocide. Bosco's account is an important addition to the stories of the Diaspora, and sheds light on the suffering of a people who lived through war, fled as refugees, and now live with the identity of traitors in their homeland. For him and many others, the war never really ended. As they continue to struggle to clear their names, they hope for justice and a new beginning in the much-loved land of their birth.

This book speaks not just to the horror of war, but to the unquenchable human spirit that rises above racial division to

see the humanity in one another. It is a tribute to courage in the darkest of times.

It speaks to the importance of faith in one another, and to the love for one's homeland in the midst of political chaos and destruction.

About the Author

J EAN JACQUES BOSCO GREW up and lived in Rwanda until the age of 28, where he had an enjoyable but short-lived career, first as a High school teacher at Rambura Secondary School and then as a Television journalist. He studied intermittently TV journalism in Belgium and France from 1990-1993.

The author holds a BA in Philosophy and Master's Degree in Sociology of Communication from the University of Lomé in Togo. JJ Bosco has several diplomas namely in Education, TV Journalism, and English as a second language

At a young age, Jean Jacques Bosco had strong ideals of contributing to his homeland's social, economic, and political growth so that all Rwandans could enjoy equal rights and opportunities. His youthful sense of hope and optimism would soon be dashed as he found himself fleeing genocide in 1994 and living in exile. During his first 2 years of exile, he had hopes of one day returning to his homeland but again watched how his countrymen, this time his Hutu kinsmen, desperately faced a second Rwandan genocide in the Congo DRC in 1996.

These two tragedies forced him to continue his road to exile in Canada, only to learn there was an international warrant to prosecute him as a participant in the 1994 genocide.

Fear, trauma and uncertainty were part of his life for 9 years before it could be confirmed that the accusations that he

was a war criminal were baseless. He has also been detained several times in European international airports due to these false allegations that followed him across the globe by way of an Interpol warrant.

Despite these challenges, Jean Jacques Bosco remains hopeful. A life-long learner, Jean Jacques Bosco is concurrently completing a BA in Criminology and Criminal Justice at the University of Fraser Valley in Abbotsford, Canada and an LLB in Criminal Law online at the University of London in England.

In Canada, Jean Jacques Bosco has owned and operated a Soccer Academy for toddlers, children, youth, and adults since 2000, and he continues to be a community soccer promotor and a community soccer volunteer. He has a family and 3 children.